I THINK,
THEREF
I D

ABOUT THE AUTHORS

THOMAS CATHCART and DANIEL KLEIN studied philosophy together at Harvard in the last millennium. Since then . . .

Danny has written comedy for Lily Tomlin, Flip Wilson, and others, and published scores of fiction and nonfiction books—from thrillers to entertaining philosophical books, such as his *Sunday Times* bestseller *Travels with Epicurus* and his most recent book, *Every Time I Find the Meaning of Life, They Change It.*

Tom studied theology and managed health care organizations before linking up with Danny to write *Plato and a Platypus Walk into a Bar . . .* , *Aristotle and an Aardvark Go to Washington*, and *Heidegger and a Hippo Walk Through Those Pearly Gates*. He is also the author of *The Trolley Problem, or Would You Throw the Fat Guy Off the Bridge?*, an entertaining philosophical look at a tricky ethical conundrum.

I THINK, THEREFORE I DRAW

Understanding Philosophy Through Cartoons

Daniel Klein
and Thomas Cathcart

ONEWORLD

A Oneworld Book

First published in Great Britain and the Republic of Ireland
by Oneworld Publications, 2018

Published by arrangement with Penguin Books, an imprint of Penguin
Publishing Group, a division of Penguin Random House LLC

ISBN 978-1-78607-446-1
eISBN 978-1-78607-447-8

Illustration credits appear at the end of the book

Printed and bound in Great Britain by Clays Ltd, Elcograf S.p.A.

Oneworld Publications
10 Bloomsbury Street
London WC1B 3SR
England

FOR JULIA LORD

I like physics, but I love cartoons.
—THE LATE STEPHEN HAWKING,
COSMOLOGIST

Contents

Contents

Introduction

Sure, we all know that the best cartoonists are keen observers of the state of our society, its quirks and ironies. We also know that some of their cartoons offer acute psychological and sociological insights. But what we often miss are the remarkable philosophical points the finest cartoonists make.

Like the best jokes, the best cartoons address philosophy's Big Questions. They explain and illustrate these perennial conundrums and their various answers in ways that are sometimes ingenious, sometimes profound, and sometimes even a bit useful. Yup, these cartoons are incisive snapshots of the Biggies.

But where did these amazingly talented philosophical cartoonists come from?

Our hunch is that they are PhDs in philosophy who couldn't find employment or, if they could, found that serving lattes at Starbucks was less fulfilling than they had hoped. Then again, these PhDs may have gone the academic route and begun teaching a course in underdetermination and provability at a small liberal arts college, only to find themselves sinking into a deep depression that was relieved only by doodling in the margins of library books. *Funny* doodles.

As a result, we have been blessed with Nietzschean cartoonists, Aristotelian cartoonists, Sartrean, Russellian, Quinean, post-Kantian, and Marxist cartoonists—even cartoonists who understand what in hell Derrida was trying to say and are able to clue us in via a droll drawing and a witty caption.

Wittgenstein once said that a serious and good philosophical work could be written that consisted entirely of jokes. (He was not trying to be funny at the time.) Undoubtedly, if Wittgenstein's subscription to *Punch* hadn't lapsed, he would have featured cartoons in his pronouncement.

Here, then, is a collection of our favourite philosophical cartoons and our annotations about what they teach us about the Big Questions in philosophy. Questions like, "Is there really any difference between girls and boys?" and "Is there a cosmic scheme?" and "What went wrong with right and wrong?" Eighteen of the most frequently asked questions in the history of philosophy.

Many of the cartoons are spot on topic, but a good number of them slip into the philosophical realm through the back door. At least, we *think* they slip in that way—we have been known to stretch a connection here and there when we whimsically get carried away. In these cases, we beg your indulgence.

Which brings us to the manner in which we have sequenced the Big Questions sections: by pure free association. Hope you don't have a problem with that.

I THINK,
THEREFORE
I DRAW

I

What's It All About, Alfie?

The Meaning of Life

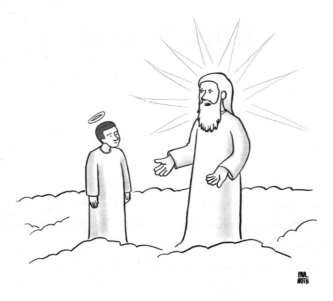

"Look, if I have to explain the meaning of existence, then it isn't funny."

Is That All There Is?

There is nothing in the cosmos that gives us more pleasure than a cartoon that hits a philosophical idea right on the head. And this is one of them. In this cartoon, the prolific comedy writer and cartoonist Paul Noth pictures a God who not only embraces twentieth-century existentialism's absurdist point of view, he hopes to wring a few laughs out of it.

The question of the meaning of life is generally considered the biggest of the big philosophical questions. If there is no answer to this one, then asking any other philosophical questions seems kind of pointless.

Of course, in modern times, many analytic philosophers find the whole meaning-of-life question pretty silly. "Hey, what is the meaning of 'meaning,' bozo?" they ask. Good question, although there is something unseemly about being called "bozo" by an analytic philosopher.

The twentieth-century existentialists—especially Jean-Paul Sartre, Albert Camus, and Samuel Beckett—concluded that not only is life meaningless, it's absurd. It's all one big Cosmic Gag. The kind where you choke laughing.

Sartre says we humans, unlike things, have no "predetermined essence." There is no objective meaning to our lives, as there is to, say, an ashtray, which has a given reason to exist, namely, to hold ashes and butts. Of course, we could hold ashes and butts too, but for us it would be a choice—the choice to be a human ashtray. (You may be wondering why anyone would choose to be an ashtray. We aren't naming any names, but we do know this one guy—we'll call him Reggie—who chose to be a doormat.) But we could also choose to be something else: for example, a hippie or a tax lawyer. Sartre says that's because our existence "precedes our essence." We aren't handed life's meaning, so it's imperative that we choose it for ourselves.

That's the downside of Sartre's dictum, that we *have* to make a choice, even if we don't want to. So, on the one hand, we're perfectly free—great. But, on the other hand, we have no objective guidelines on how to use that freedom—yikes! Who can say for sure whether it's better to choose to be a hippie or a tax lawyer? And yet we must choose—and be responsible for that choice. Suddenly, we aren't feeling so good.

Without any objective guidelines, it's an arbitrary choice. That's ridiculous. In fact, it's absurd. Doesn't that mean our very existence is also absurd? Afraid so. But it's also absurd to think we're just another object in the world with a preprogrammed essence.

So, what the hell, some of the existentialists said, let's all just embrace the absurdity of it all and keep on dancing. In his seminal essay on absurdism, "The Myth of Sisyphus," Camus likened the human condition to the man in the Greek myth who spent his

entire life pushing a rock up a hill only to have it roll down so he could start all over again. That doesn't sound a whole lot like party time. Yet, Camus concludes, "We must imagine Sisyphus happy."

Now *that's* really absurd.

The thinker who best captured the sense of existential absurdity was Samuel Beckett, particularly in his classic two-act play, *Waiting for Godot*. In that play, Didi and Gogo, the two vagabonds doing the waiting, spend the whole time not knowing who it is they are waiting for or why. It is famously a play in which nothing happens—twice.

For Didi, the real question is why they are sitting there at all. Well, they are waiting for Godot. But who the hell is Godot? And why does he never come? And how can we spend our entire lives in the vain hope that he will one day show up?

Mind you, Didi and Gogo are practically optimists compared to a man they encounter called Pozzo, who proclaims that humans give birth straddling a grave. For him, life is the brief flicker of light as we fall.

Yet, for some reason, the play makes us laugh. Try and figure.

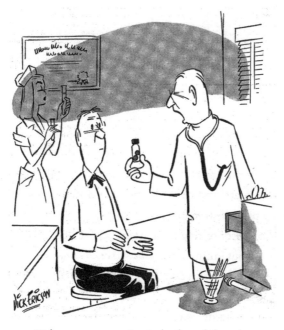

"Take one upon going to bed, and the other if you wake up in the morning."

Going for Broke

Dick Ericson's cartoon is a puzzler. Or, as a literary critic might say, "It is brimming with delightful ambiguities."

Is the doctor in the cartoon informing the patient that he is on the brink of death and there is only a small possibility that this last-chance pill will save him?

Or is the doctor telling the patient that the pill itself may very well be lethal, but taking it may be worth the risk?

In either event, things don't look very promising for the hapless patient. And if the latter interpretation is right, the patient is faced with a life-or-death decision, the ultimate risk.

When it comes to taking risks, especially the Big One, naturally we turn to the high priest of risk taking, Friedrich Nietzsche, the nineteenth-century German metaphysician and moral philosopher. In Friedrich's *Weltanschauung* (worldview), for people who want to live life to its fullest, who answer the call to be an *Übermensch* (superman), taking a life-or-death risk is the *Katze's Pyjamas* (cat's pyjamas). Life just doesn't get any more real and vivid than that.

This is the philosopher who wrote: "The devotion of the greatest is to encounter risk and danger, and play dice for death."

Nietzsche also wrote: "What makes life 'worth living'?—The awareness that there is something for which one is ready to risk one's life."

In other words, if Nietzsche were to compose succeeding panels to Dick Ericson's cartoon, we would see the patient gobble down the pill, then strut around the doctor's office with his chest thrown out and a superior look on his face . . . before toppling over onto the floor, *mausetot* (dead as a doornail).

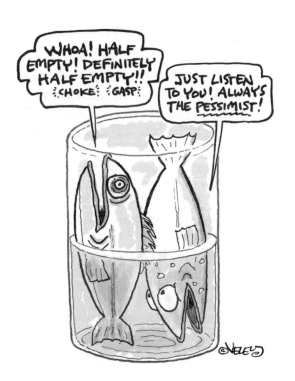

Oy, Vey!

In Bradford Veley's wonderful cartoon, we begin to grasp the formative conditions that can lead a cold-blooded vertebrate with gills and fins to become either a pessimist or an optimist philosopher.

It turns out there is "pessimism," a personal attitude, and then there's "PESSIMISM," a philosophical worldview. But do we really care? They're both downers.

Yet, philosophical pessimism actually can be quite interesting, because it challenges conventional worldviews. And challenging conventional worldviews has always been a big part of the philosopher's job description.

One popular worldview (or *Weltanschauung*) that philosophical pessimism likes to challenge is the idea of progress, ongoing progress, even the so-called progress of evolution. And the big *Weltanschauung* that philosophical pessimism disses is the one that claims that human life has any meaningful value whatsoever.

There have been philosophical pessimists in virtually every

major period of Western thought, from Heraclitus in ancient Greece to Schopenhauer and Nietzsche in the nineteenth century to many existentialists in the twentieth century, especially Camus.

Arthur Schopenhauer's name is often the first to come to mind when we think of pessimism, but whether Schopenhauer's worldview is ultimately pessimistic is a tricky question. He did believe that human existence is insatiable striving, and that striving inevitably creates suffering. So far, he would seem to qualify for the title of pessimist. But, like the Buddhist sages whose work he read and loved, he also thought there was a way out: renunciation of all desire and the adoption of an attitude of resignation. Okay, it isn't Disney World, but he did call it a "way out," so we'll give him some points on the optimism side of the ledger.

Moreover—again like the Buddha—Schopenhauer found ultimate meaning in compassion: the realization of the suffering of others and the desire to alleviate it. Verdict: optimism! Okay, maybe just nonpessimism—but that's our last offer.

There are a number of other claimants to the title of pessimist, most of them sourpusses.

But not all. Two of our favourite philosophical pessimists are exceptions because they were *very funny* pessimists: the pre-Socratic sophist Gorgias and the nineteenth-century Italian essayist and aphorist Giacomo Leopardi. Both seemed to subscribe to the idea that as long as you're going to be a pessimist philosopher, you may as well have some fun with it. Why not leave

'em laughing? This may account for why these two are less well-known than the big-time grumblers, Rousseau and Schopenhauer.

Gorgias was a popular orator specializing in parody who travelled from town to town doing his shtick for paying audiences in a period predating HBO comedy specials (fourth century BCE). His relentless theme was total nihilism; he said absolutely nothing mattered because, in the end, nothing really existed. But he delivered his philosophical pessimism with wit. Snappy one-liners, like, "Being is unrecognizable unless it manages to seem, and seeming is feeble unless it manages to be."

Rim shot!

Italian poet and philosopher Giacomo Taldegardo Francesco di Sales Saverio Pietro Leopardi (his jaunty nickname, "the hunchback of Recanati") was also a very wise wise-guy of pessimistic philosophy. In colourful poetry and prose, he lamented the mess that man—to say nothing of woman—had made of civilization, and he didn't see any improvement coming up. He got off such zingers as, "Children find everything in nothing; men find nothing in everything." And this gem, "In all climates, under all skies, man's happiness is always somewhere else."

Veley's fish with his nose in the air can relate.

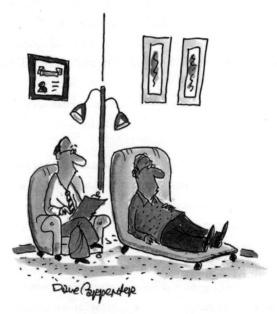

"I never realized how empty my life was
until I started tweeting about it."

All Things Considered, I'd Rather Be in Philadelphia

It's remarkable how many popular cartoons address the humdrumness of everyday life. Somehow, it must resonate with many of us. Heaven knows, this one by Dave Carpenter resonated us straight into melancholia.

For Martin Heidegger, the twentieth-century German existentialist and phenomenologist, the problem of "everydayness" was fundamental to his philosophy of "being-in-the-world." He saw us as "thrown" into the world without a clue of what we are doing here, so we cast about for a satisfying existence—what he calls a "project." Religion or some other ideology, including seeing everything through the eyes of objective science, often does the trick for that.

But inevitably, Heidegger says, we "fall" into the everydayness of conventional life, its morality, its customs, its chitchat about the passing scene—its *Monday Night Football*, its *Blue Bloods* reruns, tra-la, tra-la. In other words, we do not create our own project, we simply fall into one. And when we become conscious of our

fall—like when we tweet about the actual goings-on of our everyday life—the old humdrums set in.

Viktor Frankl, a Viennese existentialist and psychotherapist, described a similar phenomenon in more down-to-earth terms in his magnum opus, *Man's Search for Meaning*. Wrote Frankl, "'Sunday neurosis' [is] that kind of depression which afflicts people who become aware of the lack of content in their lives when the rush of the busy week is over and the void within themselves becomes manifest."

Happily, Frankl believed we could emerge from these Sunday blues by self-creating a meaning to our lives. He said man's greatest gift is the ability to "will meaning," and he set up a new school of psychotherapy—logotherapy—devoted to helping us determine meaning in our lives. Thanks, Viktor, we're feeling better already. Well, marginally.

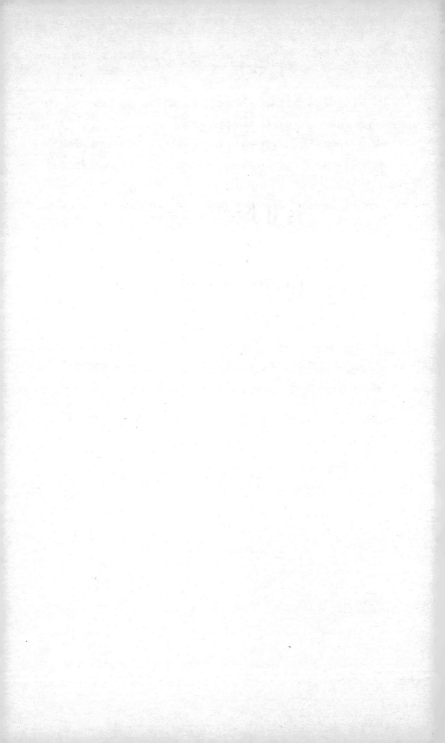

II

Is It Now Yet?

The Philosophy of Time

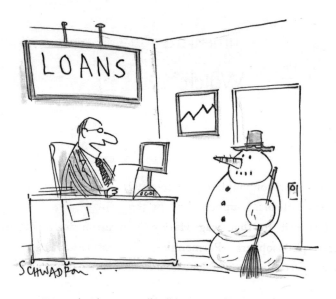

"How do I know you'll still be around in a year?"

Time Is a River—
Watch Your Step

If you're still contemplating suicide after reading the last section, here's a little picker-upper—and it's about time.

Leave it to that wag Harley Schwadron to incorporate three philosophers—Parmenides, Heraclitus, and J. M. E. McTaggart—into a single cartoon meditation on the nature of time.

Using some fancy and fascinating logic, the pre-Socratic Greek philosopher Parmenides concluded that the One True Fact about the universe—and everything in it—is that it is permanent. Everything that is, always was and always will be.

For Parmenides, time was a logical impossibility. Time is the measure of change and motion. Both change and motion, he said, involve something passing out of existence and something new coming into existence in its place. But how can something come into existence? It must have been *nothing* before that. But "nothing" can't exist. If it did, it would be *something*, right? So,

change and motion must be illusions, and without change and motion, there's no such thing as time. QED!

Enter the Father of Flux, Heraclitus, a contemporary of Parmenides (but then, to Parmenides, everyone was a contemporary). Heraclitus said the One True Fact about the cosmos is that it is always and endlessly changing. Nothing is permanent, like, say, a snowman on the verge of puddledom. The primary principle is *flux*.

When Heraclitus famously wrote that a man cannot step into the same river twice, he meant that the river just keeps rolling along, with new water sloshing by each moment. It is in constant flux. Some scholars believe he also meant that the river-stepping man himself is constantly changing too. That guy named Cleandros who stepped into the river yesterday is a different guy from the identical-looking Cleandros doing some foot dipping today, because humans, too, are in constant flux. In other words, it's not just snowmen who are fluid, so to speak.

The work of both Parmenides and Heraclitus has come down to us only in fragments, so we don't know exactly what either of them meant. Might Heraclitus agree that the snowman exists forever in some form: water, then water vapour? A carrot nose, then vegetable rot? If so, is that really inconsistent with Parmenides's idea that everything is permanent? Might modern scientists just say that both of them would accept the law of conservation of matter (for any system closed to all transfers of matter and energy, the mass of the system must remain constant over time)? It's hard to say, especially since that law wasn't formulated until a couple

of millennia after both Parmenides and Heraclitus were particles of dust.

In the early twentieth century, British philosopher J. M. E. McTaggart reframed Parmenides's notion with an amusing twist. In "The Unreality of Time" McTaggart speculated that time isn't a flow from past to present to future. Rather, every moment of what we *call* the past, present, and future is, as Parmenides said, eternal. *And time is just a construct we place on it.* Or as Woody Allen put it, "Time is God's way of keeping everything from happening at once."

In any event, it seems unlikely that the loan officer's assessment of the snowman's creditworthiness is going to turn on what position he takes on the metaphysics of time. Loan officers just don't seem to get the practicality of philosophy.

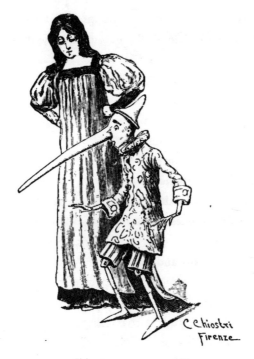

"My nose grows now!"

A Paradox Walks into a Bar

This cartoon is adapted from Carlo Chiostri's illustration in a 1901 edition of *Le Avventure di Pinocchio*. It illustrates the "Pinocchio paradox," about which, more later. But first, in order of time—if, indeed, time exists—we will take a quick look at the granddaddy of paradoxes, Zeno of Elea, who thought it doesn't exist. Time, that is.

Still with us? Zeno and Parmenides were homies. In fact, Zeno studied with Parmenides and totally bought into Parmenides's no-motion notion, which proves that time is an illusion. And dutiful student that Zeno was, he thought up a bunch of proofs of his prof's idea that motion was logically impossible. These proofs became big crowd-pleasers. They are known as Zeno's paradoxes.

For example, Zeno asked us to picture an arrow in flight. Now, freeze any moment in that flight. (Think: Take a still photograph.) Now, freeze another moment in its flight. (Take another still photograph.) We can theoretically take an infinite number of these still photographs, but we still won't be showing any motion—just a whole lot of still photographs. We can string

them together in a movie and create, as movies do, the illusion of motion, but no number of consecutive moments in the flight of the arrow will constitute motion.

Another of Zeno's famous paradoxical proofs that motion is impossible involves a racetrack. A runner is attempting to run around a track. He runs halfway around. Then he runs half of the remaining distance. Then he runs half of the still-remaining distance. Then he runs half of the *still*-remaining distance. Then he runs half of the STILL-remaining distance. Clearly, the poor man can't ever run the whole way around. He can keep covering half of the remaining distance an infinite number of times, but he still won't get the whole way. Ever. Hmm, must be that there's no such thing as motion.

In any event, Zeno became even more famous as the Godfather of Paradoxes than he was as the Man Who Disproved Motion.

Zeno's paradoxes about motion involve the physical world, but the Pinocchio cartoon illustrates another type of paradox, the *logical* paradox. (Logical paradoxes contain statements that refer to themselves, so they are also called "paradoxes of self-reference.") Pinocchio's nose famously grew whenever he said anything untrue, or, as logicians like to say, "if and only if he said something untrue." So, what are we to make of his statement "My nose grows now"? Is it true or false? If he's telling the truth, then his nose will *not* grow, thereby showing his statement, "My nose grows now," to be false. Or, if he's not telling the truth, then his nose *will* grow, thereby showing his statement to be true. Yup, it's a paradox, all right.

The Pinocchio paradox is a version of the old liar's paradox, first recorded by Eubulides of Miletus in the fourth century BCE. Eubulides asked, "A man says that he is lying; is what he says true or false?" If it's true, then it's false; and if it's false, then it's true. Our heads spin (unless, of course, motion is impossible).

Paradoxes (from the Greek, meaning "contrary to opinion") have played a paradoxical role in philosophy for millennia because they show one way in which the laws of logic and physics fall down on the job, or seem to, anyway.

In any event, after a few drinks, a nifty paradox can be good for a laugh. Next one's on us. Paradox, that is.

"Pretty good. The ending was a bit predictable."

Are We There Yet?

Okay, let's say time does exist just the way we thought it did—one thing after another, ad infinitum. But where is it all leading?

In John McNamee's brilliant but chilling cartoon, the wise-guy angel is informing God that the grand finale of his little creation—the world and its inhabitants—was easy to determine from the get-go.

Clearly, the angel buys into Aristotle's concept of "telos"—at least, up to a point.

Telos figured prominently in both Aristotle's physics and his metaphysics. It means the inner goal of everything, including human beings. He said this goal is built into everything from the outset. Think of a sunflower seed: Its inner goal is to *become* a sunflower, complete, of course, with new sunflower seeds.

So the angel is saying that, given the telos of humankind on Earth, blowing up the whole shebang is built in from the beginning. It's inevitable.

But here is where the angel and Aristotle part ways. Aristotle

had a determinably sunnier view of the telos of human beings. He wrote that our inborn purpose is happiness, and that it's achieved by living a virtuous life.

Oops, there's the catch!

Bombs away!

"You do realize this means
2,000 years of Christmas records."

Determinedly Deterministic

Could Aristotle be right? Over time, is the whole cosmos heading in one—and only one—direction? Laplace thought so. And so, apparently, did determinist cartoonist James Whitworth.

Pierre-Simon, Marquis de Laplace, a French mathematician, physicist, astronomer, and metaphysician of the late eighteenth and early nineteenth centuries, created a thought experiment that still resonates today with philosophers and video game makers. Called "Laplace's demon," it goes like this:

> We may regard the present state of the universe as the effect of its past and the cause of its future. An intellect which at a certain moment would know all forces that set nature in motion, and all positions of all items of which nature is composed, if this intellect were also vast enough to submit these data to analysis, it would embrace in a single formula the movements of the greatest bodies of the universe and those of the tiniest atom; for such an intellect nothing would be uncertain and the future just like the past would be present before its eyes.

Laplace starts with the physical laws of classical (Newtonian) mechanics that describe the causal forces that put bodies in motion. It is a universe in which every event has a cause—a form of determinism. Then Laplace asks us to imagine a Super Mind that knows exactly where everything in the universe is right now and the momentum of every atom in it. Bingo, Super Mind can calculate everything that ever happened and everything that will happen!

That's not just a fantasy, said the marquis; it's theoretically possible.

Flash-forward (no problem for a Super Mind) from 1814, when Laplace published his thought experiment, to the year 1963, when the American meteorologist and chaos theorist Edward Lorenz published his famous thesis, subsequently called the "butterfly effect."

The butterfly effect took the idea of endless strings of cause-and-effect to a new, mind-boggling level. Lorenz said that the flap of a butterfly's wings in one part of the globe can put into motion a chain of cause-and-effect that can cause a hurricane halfway around the globe. Generalized, the butterfly effect postulates that over time a small event in one place can generate big changes in other places, and it happens all the time. Think about that the next time you sneeze.

Cartoonist James Whitworth aligns himself here with both Laplace and Lorenz. His three wise men approaching the manger have quickly calculated a long series of causes and effects that leads directly to Bing Crosby's bestselling *Merry Christmas* album. We can even hear the Laplacian demon crooning along, "I'm dreaming of a white Christmas / Just like the ones I used to know."

However, Laplace wrote two hundred years ago, when the universe was still believed to operate deterministically. Today, quantum theorists tell us it ain't so. Rather, they say, the universe operates *probabilistically*. We can calculate the probability of any particular state of affairs following the present state, but we can't predict with certainty how any one element in the present scheme of things will act. Bing's version of "White Christmas" may have been the most *probable* outcome of the birth in the manger, but, at the outer edges of the bell curve of probabilities, it's just possible that we might have ended up with Crosby crooning "Hava Nagila." Or Queen Elizabeth's recording of "We Three Kings of Orient Are."

III

Is There Really Any Difference between Girls and Boys?

The New World of Gender Philosophy

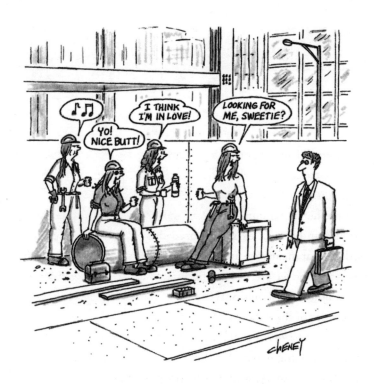

The Masculine Mystique

Cartoonist Tom Cheney is a philosopher of many levels! First, he asks us to consider the existentialist feminism of Simone de Beauvoir.

Like her paramour Jean-Paul Sartre, Beauvoir believed that for human beings, "existence precedes essence." As mentioned earlier, that means we are not created from a mould but are free to create who we are. When she applied this ethic to gender roles in her book *The Second Sex*, the result was a cultural explosion on both sides of the Atlantic.

This was 1949. French middle-class women were disadvantaged in getting married if they didn't have a dowry. And, with or without a dowry, women certainly were not likely to become philosophers.

Beauvoir argued in the book that one is not born "a woman"; one *becomes* an *individual* woman by creating her own essence. She said men keep women "in their place" by creating an aura of mystery around them, a tactic later critiqued by Betty Friedan in *The Feminine Mystique*. Beauvoir also argued that groups at the top of the social hierarchy—because of class, race, or

gender—always treat those lower in the pecking order as "Other." In the social order of gender politics, this means patriarchy.

Applying her existentialist ethic, Beauvoir maintained that gender roles are not *essential* to who we are; they are "socially constructed," to use the lingo of later feminist thinkers. And, even as women push the limits of gender roles, society's assumption remains that traditional male roles are the norm. (Her father, for instance, admiringly said, "Simone thinks like a man." *Dad!*)

The women in Tom Cheney's cartoon have broken out of traditional female roles by adopting traditional male roles—and behaviour. They have thereby achieved a certain degree of liberation. But Beauvoir would say they are still constrained. They are still aping men, so to speak. They have not yet freely created brand-new roles.

It's for this reason that we conclude that cartoonist Cheney here is channelling not only the feminist thinkers but also the social and ethical philosophy of another influential twentieth-century philosopher, John Rawls.

Rawls is probably best known for a thought experiment called the "veil of ignorance." He asks us to imagine an "original" status in which we know nothing about what our role will be in the social order. We don't yet know what our talents or our social class or our particular social position—or even our tastes—will be. From this original position, we must choose how we think society should be ordered. Who gets what rights? Who gets what resources? Who gets which social positions? Are we likely to choose a society that is based on slavery, when we know there's a chance that we will be among the slaves? Will we choose a society

in which the top 5 percent have more wealth than the remaining 95 percent, when we know that there's a 95 percent chance we'll be in the bottom 95 percent?

Cheney seems to be suggesting in the cartoon that, behind the veil of ignorance, even men might not choose a sexist society, knowing there's a 50 percent chance they will end up on the wrong end of the stick.

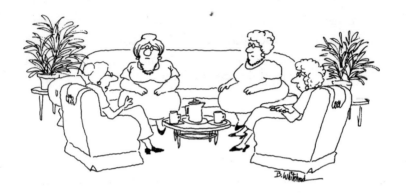

"I think you're mistaken, Mavis—I'm quite sure an offensive lineman can be an eligible receiver if he lines up as a tight end!"

Sugar and Spice
and Everything Nice

Male reader advisory: Do not laugh at Bill Whitehead's cartoon riff on gender roles. We are telling you this for your own good.

These grandmotherly women, engaged in some inside-football talk, have simply transcended the social construct of gender differences and gender roles. Why should only men be knowledgeable about football? Like, really? The women in Bill Whitehead's cartoon are not allowing the culture in which they live to determine what is or isn't appropriate behaviour for women. And in so doing, they are taking a step toward levelling the playing field, so to speak, between women and men. (It's fascinating to note that this cartoon appeared in the family magazine the *Saturday Evening Post* in the year 1988.)

In her revolutionary book *Gender Trouble: Feminism and the Subversion of Identity*, the contemporary American feminist philosopher Judith Butler argues that gender is totally "performative," that is, taking on a role, and that nobody is a particular gender from the outset.

This puts Butler in direct opposition to the psychologist and philosopher Sigmund Freud, who famously wrote, "Anatomy is destiny," meaning that the gender one is born with is a chief determinant of his or her future personality traits. By this, Freud did not simply mean that, say, on a hike deep in the woods, one gender has an advantage over the other when it comes to peeing. No, he meant that, because of their physical differences, girls and boys are genetically programmed to develop different types of attitudes, interests, reactions, and even character traits. It all comes with the package.

Long before feminists took issue with Freud's dictum, anthropologists and sociologists pointed out that so-called male and female roles and traits differ widely in different historical eras, not to mention in different cultures. So what, exactly, was it that was given at birth, doctor? Weren't these roles and traits dictated by a particular culture and its norms at a given historical moment?

Then, of course, there is the question of people who say that they were born in the body of the wrong gender, so they would like hormonal therapy and surgery to correct this anatomical mistake. What would the father of psychoanalysis say about that one?

So, back to the women discussing "tight ends." Might one of them go on to argue that women should be permitted to play in the National Football League?

Don't laugh, guys.

In fact, don't even go there.

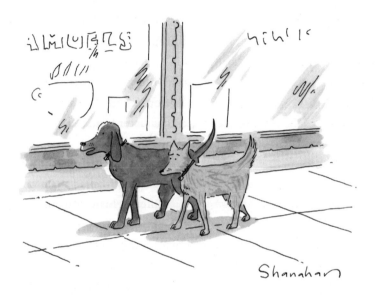

"So he rubbed your belly and it felt
good—that doesn't make you gay."

Any Questions?

The "Q" at the end of "LGBTQ" usually stands for "queer" or "questioning," the questioning of one's sexual identity and preferences. And sexual identity is exactly what is perplexing the belly-rubbed doggie in Danny Shanahan's wonderful cartoon.

It can get complicated. These days many people who are "L," "G," "B," and "T," not to mention "S" ("straight"), view their identities as flexible, not permanently fixed one way or another, so there is a lot of Questioning going on with everyone, doggies included. People are questioning not only whether they are Ls or Gs; they're also questioning whether they're Ts. Gender theorists are distinguishing between our "assigned" gender—the one on our birth certificate—and the gender with which we identify. We even have a new word, "cisgender," to refer to people who do identify with the gender they were assigned. These are the people we used to call "people."

Moreover, the choices for gender identity are expanding geometrically beyond the boring, old-fashioned two, and some people are identifying themselves as "nonbinary," a term many

binary minds are grappling with. Some gender scholars have pointed out that sexual identity can change with circumstances. For example, many people whose behaviour is usually heterosexual may adopt homosexual behaviour in prisons. What's going on here?

Good questioning.

All of this leads us to a sexual identity question that has been hotly debated by scholars for millennia: Was the ancient Greek poet Sappho of Lesbos really a lesbian or has she mistakenly become the poster girl for lesbians and gender scholars?

In addition to her sexual orientation, there is a whole lot more that is unknown about Sappho, including the actual content of her poems (only a few fragments remain). What is known is that she exerted a great influence over many of her contemporaries, especially the women to whom she read her poetry at women-only gatherings. These were gorgeous poems about the sublimity of Love, arguably more vivid, rhapsodic, and compelling than the work of any of the male poets of her day.

Here are a couple of lines from one of Sappho's poems that beseeches the goddess Aphrodite not to forsake her love for her:

> Don't shatter my heart with fierce
> Pain, goddess . . .

Lesbian poetry?

Maybe, as they say, you had to be there. In ancient Greece, expressions of love between teachers and students (not to mention between gods and supplicants) who were assigned the same

gender were not only condoned but said to facilitate learning. A reading of Plato's *Symposium* confirms that. So maybe it is a question of circumstances.

Next questioning?

If It Works, It's Right, Right?

The Epistemology of Pragmatism

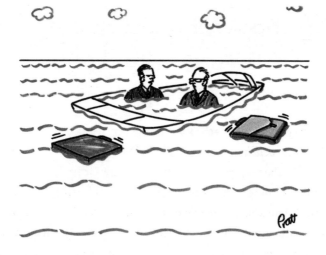

"It still works in theory."

Practice, Practice, Practice

It's pretty clear that cartoonist Paula Pratt was a student of the nineteenth-century American philosopher Charles Sanders Peirce. By the way, that's not a typo; his name really did violate the rule "i" before "e," except after "c," and he pronounced it "Purse." And that's not the only rule he broke. He staked out new territory with his declaration that "truth is what works," and he is therefore known in the history of philosophy as a "pragmatist." His own term for himself was "fallibilist," meaning, as he said, that "people cannot attain absolute certainty concerning questions of fact." But in the meantime, we have to go with our best shot, based on current evidence, and see how it works out in practice.

If, as in the case of Paula Pratt's boaters—who, for reasons best known to themselves, are boating in business suits and possibly carrying their fishing gear in briefcases—it doesn't work out all that well, then we need a new theory. That new theory then also has to pass the workability test. If that sounds like common sense, it's because we haven't said the punchline yet: *No* theory is absolutely certain in the usual sense of "corresponding

to reality." We like to think that Copernicus's theory that the earth revolves around the sun is right, right? And that Ptolemy's theory that the sun revolves around the earth is wrong, right? Admittedly, the Copernican theory did endure a long time as a working hypothesis, but only up to the point when Einstein came up with a theory that worked even better. Someday someone else may come up with one that works better yet.

The man in the boat is apparently clinging to his theory about its seaworthiness, despite the fact that this theory clearly does not hold water. His bespectacled colleague is showing signs of consternation. Perhaps he is frantically wracking his brain for an alternative theory, one that is more likely to lead to a drier outcome. But, before we give him too much credit, let's reflect on the fact that he may or may not realize that his new theory will not be infallible either. It will serve only until someone demonstrates that a new theory works even better as a guide to action.

On the other hand, he may be *more* of a pragmatist than we think. He may be skipping theory altogether and instead reflecting on the fact that, as a practical matter, arriving at their meeting in soggy suits isn't going to work out well either.

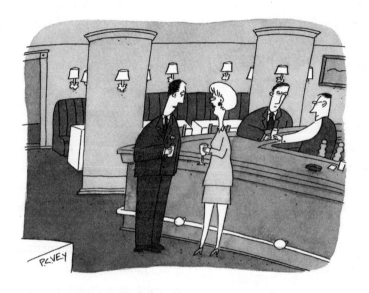

"They say I'm practical in bed."

Sexual Practices

Golly day, as Mother used to say. What could the woman in P. C. Vey's naughty cartoon possibly mean by "practical in bed"?

That she brings extra blankets in case it gets cold?

That she wears an antisnoring mouthpiece, so she shouldn't be a bother to her bedmate?

That she has the birth control situation perfectly under control?

Vey's joke is in the oddity of using the term "practical" in the context of a sexual encounter—and especially the term's goofy ambiguity in that situation.

But we're not fooled. We know exactly what she means. Clearly, the young woman has a PhD in philosophy with a specialization in late-nineteenth- and early-twentieth-century American philosophers. (You can see that distinctly in her practical slip-on pumps.) So, by "practical in bed," she undoubtedly means that she makes judgments in bed based on William James's pragmatic theory of truth.

Along with Charles Peirce and John Dewey, William James was a founder of the uniquely American school of philosophy known

as pragmatism. While Peirce had concentrated on workability as a key to creating and understanding scientific theories, James expanded pragmatism to include personal beliefs. James held that the truth of *any* theory or belief, whether scientific or ethical or metaphysical or religious, depends on its usefulness, and that we therefore should be open to reassessing our "truths" as we see how useful they are in each new human experience. No absolutism here. Nothing in the universe simply is what is and always will be. Even questions like "Is there free will?" or "Is there a God?" are only meaningful in terms of how useful our answers are.

This notion of truth as usefulness was especially appealing to James, because in addition to being a philosopher, he was also a psychologist, where experience was constantly demonstrating the usefulness or uselessness of his ideas.

So, said James, we create truth in the process of living satisfyingly. "The ultimate test for us of what a truth means is the conduct it dictates or inspires."

Obviously, what the PhD in the cartoon is communicating to her prospective bedmate is that she has no fixed idea of a "good lover" or a "satisfying sexual experience"; she will be able to make that judgment only after assessing the usefulness of the real experience.

Or, in other words, "Let's see how it goes, hon."

V

What Is the Fairest Way to Divvy Up Goods?

Capitalism, Marxism, and Libertarianism

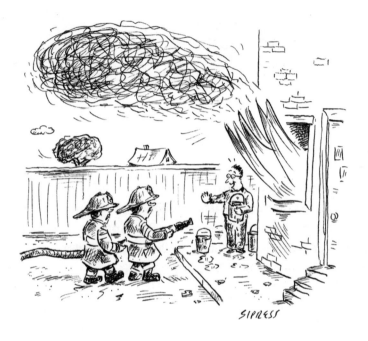

"No, thanks—I'm a libertarian."

Freedom's Just Another Word for "Leave Me Alone"

It's rare that a political cartoon cuts straight from a modern political topic to a fundamental issue in political philosophy, but David Sipress's now-famous firemen cartoon does just that. It zooms out from the twenty-first-century libertarian movement to the nineteenth-century British philosopher John Stuart Mill and his seminal essay "On Liberty."

In that book, Mill laid out his deep misgivings about the limitations on freedom that are invoked by the state, whether it's a kingdom or a democracy. At times, he was even more worried about the tyranny of majority rule than that of monarchy.

Maximum liberty of the individual was paramount for Mill, as long as it didn't seriously screw up anybody else's life. As one wag put it, "Your right to swing your arm leaves off where my right not to have my nose struck begins." Other than that, swing away! And if you cause harm to yourself—say, a displaced shoulder—that's your affair, and the state has no business trying to protect you from yourself.

It's easy to see why Mill became capitalism's darling. His idea of the way to divvy up goods was laissez-faire economics: Let the economy run as it will and keep the government out.

Wrote Mill: "The only freedom which deserves the name is that of pursuing our own good in our own way, so long as we do not attempt to deprive others of theirs, or impede their efforts to obtain it. Each is the proper guardian of his own health, whether bodily, or mental or spiritual. Mankind are greater gainers by suffering each other to live as seems good to themselves, than by compelling each to live as seems good to the rest."

His belief that the individual is "the proper guardian of his own health" suggests that, if Mill were around today, he would probably say that an individual's smoking of cigarettes is none of the state's business—well, as long as the "secondhand smoke" thing didn't get ridiculously out of hand. No "sin tax" for J.S., and definitely no "nanny state."

Of course, somebody would be bound to retort that the individual's health is *everybody's* business, because everybody pitches in for his medical care, via either insurance or taxes or both, not to mention the family members who would have to take care of him as his lungs rot.

Which brings us back to the firemen being turned away from the burning house by a self-styled libertarian.

The American libertarian movement came of age in the twentieth century and forthwith became a political party that runs candidates for public office. Here's the Libertarian Party's mission statement: "Libertarians support maximum liberty in both personal and

economic matters. They advocate a much smaller government; one that is limited to protecting individuals from coercion and violence. Libertarians tend to embrace individual responsibility, oppose government bureaucracy and taxes, promote private charity, tolerate diverse lifestyles, support the free market, and defend civil liberties."

Given this ideology, it's not a total stretch to say that libertarians might—at least in principle—favour putting out their own fires over forking over money to the communal coffers (taxes) to sustain an ever-ready fire department.

Under the circumstances pictured, however, that seems like a really dumb decision, and not one any real-life libertarian would make. To make his point, cartoonist Sipress employs a method of argument that derives from the ancient Greek philosopher Xenophanes of Colophon: the old *reductio ad absurdum* (Latin for "reduction [of the argument] to absurdity").

It turns out that Xenophanes's *reductio* is the key to many successful cartoons.

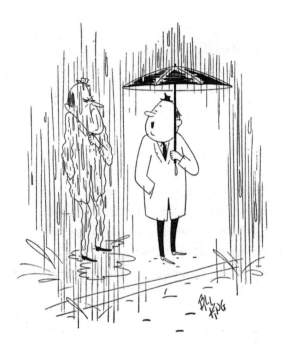

"We needed this."

An Umbrella Theory of History

Here it is: Marxism in a rainstorm.

It took us a few minutes to realize that between the raindrops, the brilliant cartoonist Bill King was offering us an object lesson in the Marxist dialectic—the struggle between the people who own umbrella factories and the exploited workers who actually make the umbrellas but can't afford to buy them.

When the nineteenth-century philosopher and economist Karl Marx surveyed the history of human societies, he found a single scuffle as the basis for all the unrest in the world: the struggle between the exploiters and the exploited. Marx identified the exploiters in the modern era as primarily the capitalists—they not only had the money to buy umbrellas but owned the factories that manufactured them. At the bottom of the ladder were the umbrellaless folk, the exploited workers, or "proletariat." They soaked up the downpour, possibly after having spent fourteen hours labouring at the umbrella works. It's enough to foment a revolution. And it did. Several.

A nice touch is the caption, "We needed this," as in, "Rain is good for the umbrella business, sucker."

But hold on, there may be a subtler message here. The guy pictured with the umbrella could very well be just another schlub who happens to have just enough disposable cash to spring for an umbrella but is a worker himself (although it could be argued that his tie and his tiny hat mark him as a member of another class identified by Marx, the petite bourgeoisie). In any event, many Marxists have observed that the proletariat have a tendency to pick fights with the people only a single rung up the ladder from where they stand: say, the people working in the shipping department of the umbrella factory, where the work is a bit less stressful. This distracts the exploited from waging war with the real enemy, the exploiters, who own the whole company. The exploiters, of course, love to see the "little people" fight with one another—possibly duelling with umbrellas—instead of revolting against them, the exploiters.

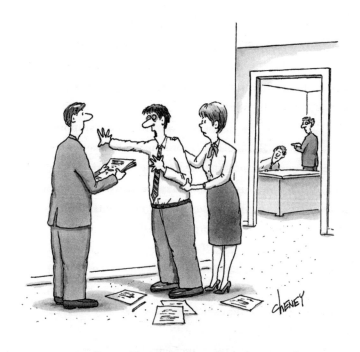

"Really, I'm fine. It was just a fleeting sense of purpose—I'm sure it will pass."

The Dehuman Condition

This cartoon by the incisive Tom Cheney hurts, and the recent German American philosopher Herbert Marcuse would have known exactly why: because, he said, under capitalism, workers are not only exploited financially, they are *dehumanized*.

Picking up from where Karl Marx left off, Marcuse delved into how working for the Man affects us psychologically. He said that it is not just a case of material deprivation—trying to get by on a paltry wage—it is a case of soul deprivation. Being enslaved by capitalism, those in the proletariat lose the very essence of their humanity.

In his seminal work *One-Dimensional Man*, Marcuse wrote that workers see themselves as parts of the products they are making for the Man. Further, they also begin to identify with the goods they consume. "The people recognize themselves in their commodities; they find their soul in their automobile, hi-fi set, split-level home, kitchen equipment . . ."

Marcuse, like the French existentialists, made a deep impression on mid-twentieth-century young people. He changed the way many of them looked at themselves, at their lives and their futures.

This is not something that, say, the twentieth-century logical positivist philosophers, like A. J. Ayer, can be said to have done. Personally, we don't know anyone who quit her job and took to the road in a tie-dyed T-shirt because of Ayer's rejection of synthetic a priori propositions.

But counterculture heroes such as Angela Davis and Abbie Hoffman were radicalized by reading *One-Dimensional Man*. It articulated their frustration and anger toward modern society.

Veteran *New Yorker* cartoonist Tom Cheney was a teenager in the 1960s and '70s, but we bet he knew folks who experienced zero sense of purpose in their jobs.

VI

You Call This Living?

Hedonism, Stoicism, and Mindful Living

"There goes Daddy to the park again!
And do you know what he does in the park?
He sits! That's what he does. He sits!
He goes to the park and he just sits!"

Pleasure on a Modest Scale

In this cartoon by terrific stylist George Booth, "Daddy" is clearly a hedonist. But what kind of hedonist? It turns out hedonism comes in different flavours.

But before we get to those flavours, let's start with the ur-question: What is the best way to live? According to the hedonists, it's to have as much pleasure as you can pack into your life. What else could it possibly be?

It turns out there are several other popular philosophical answers to the best-way-to-live question. To name a few: to lead a good and just life; to lead a life that would please the gods or just one God, if that's all there happens to be up there; to lead a heroic life that transcends the ordinary lives of other less conscious folk; or, of course, to adopt the ever-popular "There is no best way to live, so just keep on truckin'."

But the hedonists have always attracted a large body of followers. Aristippus (435–356 BCE), a Greek Libyan, was one of the first recorded philosophers to promote the pleasure principle as the entire point of life. If it *feels* good, it *is* good—end of story. No exceptions or qualifications.

But then, not long afterward, another Greek philosopher, Epicurus (341–270 BCE), staked out his own curious form of hedonism, one that is so full of caveats about what pleasures should be avoided that reading him can feel like a Sunday school lesson. In one of Epicurus's famous aphorisms (he was a prince of sound bites), he wrote: "If thou wilt make a man happy, add not unto his riches but take away from his desires." And in another: "We must exercise ourselves in the things which bring happiness, since, if that be present, we have everything, and, if that be absent, all our actions are directed toward attaining it."

In short: All the pleasures we need are right there in front of us, so dig them to the fullest. Going off in search of other, supposedly better pleasures puts us on the path of endless yearning, which isn't any fun at all.

So "Daddy" in Booth's cartoon is clearly an Epicurean hedonist. Despite his family's scepticism, Daddy knows that he is going to have a supremely pleasurable experience walking to the park and sitting on a bench. He can gaze at the sky through a filigree of leaves, he can pat a passing dog, he can greet his friends, he can hum a little tune. His pleasures, if he really attends to them, are sublime and endless. Plus, he gets a bit of respite from this wacky household.

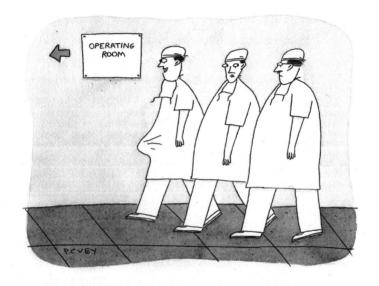

*"If you ask me, Foge has the completely
wrong attitude about gallbladder surgery."*

What the Stoic Brought

Before we get into how P. C. Vey's cartoon illustrates an interesting aspect of Stoicism, we need to come clean: We worried that this one crossed the line into bad taste. It's hard to tell these days.

At a recent conference on the philosophy of humour, many academics insisted that the key to meaningful funny stuff was transgressiveness. They said that Lenny Bruce had it right in the title of his autobiography, *How to Talk Dirty and Influence People*. Dirty gets attention; dirty sways minds.

But what about shock for shlock's sake? And when does transgressive become just plain juvenile?

While the jury remains out on these questions, we'd like to slip in a few words about Stoicism.

For the Stoics (heyday: fourth century BCE to second century CE)—as well as for their rivals, the Epicureans—philosophy was not just an intellectual endeavour, it was a way of life. They saw philosophy as a method of putting into practice a set of rational principles that would transform them and empower them to live

their best life. Many have compared the Stoic philosophy and its application to what is known today as cognitive behavioural therapy. Because the Stoics thought the world has a rational structure, they taught that the appropriate way to live is to align our lives with that structure and choose only those actions that are genuinely natural to us as rational creatures and that objectively contribute to our well-being.

This requires that we adopt an attitude of *apatheia*, which looks like it should mean "apathy" but is probably better translated "equanimity." The sage who has conquered his passions and attained the attitude of apatheia is free to order his life according to reason. This does not mean that he has no impulses, only that they do not control him; nay, *he* controls *them*. And to an astounding degree. Wrote the Stoic philosopher and Roman emperor Marcus Aurelius, "If you are distressed by anything external, the pain is not due to the thing itself, but to your estimate of it; and this you have the power to revoke at any moment."

The Stoics thought that pleasure, too, is best kept under rational control, resulting in an equanimity that is in harmony with the universe. As it turns out, then, the Stoics' "apathy" and Epicurus's "hedonism" are not as different as they at first appear. The Stoics were just somewhat more rigid when it came to pleasure.

Stoic cartoonist P. C. Vey is here giving us a Stoic critique of one surgeon by another. All three surgeons no doubt have an impulse for surgery. What distinguishes the third is that he has

a *passion* for it. Not good from a Stoic point of view. Probably not good from the patient's either.

Incidentally, we have it on good authority that the "P.C." in Vey's name does *not* stand for "Politically Correct."

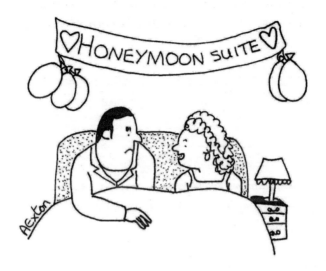

"Actually, I don't believe in sex after marriage either."

Living in Sin:
A Radical Interpretation

We really shouldn't laugh at Andrew Exton's cartoon. The bride pictured here is obviously deeply religious, a devoted follower of Saint Augustine, and therefore has an elevated view of hedonism.

For many, the first question that comes up when we think about the role of pleasure in choosing a way of life is "What about sex?" Here we turn to Saint Augustine for guidance, just like the blushing bride.

Augustine of Hippo had been a bit of a rake back in the late fourth century, and even had a child out of wedlock. But his mother, Monica, a devout Catholic, gave him a good talking-to and ultimately engineered a breakup with his mistress.

A year later, Augustine became a monk and devoted himself to a life of chastity. He believed that all sex was wrong because it's exciting, and exciting is bad because we lose control. If we could have sex (for procreation) without excitement, Augustine was okay with that. But, said he, it's impossible for a man to create an erection by

pure detached willpower. (We're not making this up. Augustine actually said it.)

But wait, he thought, lust is necessary to maintain the species! So why would God have used unholy lust for this purpose, if it's not a godly activity? It must be that if Adam and Eve hadn't gotten themselves thrown out of Paradise, procreation would have happened in a more controlled way. Men would have been able to will their own erections without lust, just as some men, he said, are able to wiggle their ears, and some can even wiggle one ear at a time. (Again, Saint Augustine actually used this example. Funny guy.)

The problem is that here, in the post-Paradise world, we've lost that ability. Not the ear thing so much, but the willed erection. We're condemned to live with our concupiscence, our insatiable desire. And not just Adam and Eve. We've all inherited their alienation. *Peccatum originale.* Original sin.

Augustine ended up as Bishop of Hippo and wrote a number of influential theological works. Both he and his mother were later canonized, although his mistress wanted them cannon-ized.

Cartoonist Andrew Exton totally gets it. The bride is of the Augustinian persuasion: She thinks that sex is unholy both inside and outside of marriage. Of course, it's a pity she didn't see fit to tell the groom beforehand, but we can see his wheels turning already: "Well, I once taught myself to wiggle my ears, so who knows? It's worth a shot. On the other hand, why would I want to do that?"

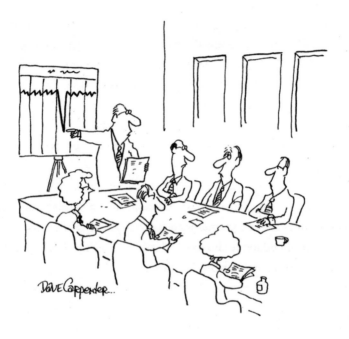

"I understand this was the day you seized, Ferguson?"

Carpe Diem!

We were knocked out by cartoonist Dave Carpenter's eloquent critique of the Roman poet Horace. Indeed, we were seized by it!

Leave it to Horace to cut through all the intellectualizing about pleasure and just let it all hang out!

Carpe diem! Seize the day! he cried.

It all started back in 23 BCE, when Horace memorably wrote:

> Strain your wine and prove your wisdom; life is short; should
> hope be more? . . .
> Seize the present; trust tomorrow e'en as little as you may.

Horace lived during the period when Rome was transformed from a republic to an empire, and philosophy had turned inward, expressing attitudes that individuals might adopt to cope with their political insignificance. At the Academy, founded in Athens centuries earlier by Plato, Horace was influenced by the works of the Stoics and Epicureans, who had advocated self-control and restraint. Eventually, Horace urged

his countrymen to drop the self-control and just seize the day, though he had little to offer as to how that might have any social impact.

Scholars think that to Horace, *Carpe diem* probably meant something more like "Just do it!" than today's "Be in the moment." But, having supported Brutus's failed attempt to return Rome to a republic, he had little notion of how "just doing it" would bring about social change.

Enter cartoonist Dave Carpenter with his brainy analysis of the ambiguities inherent in Horace's dictum. Seize *which* day? Just do *what*? Seize it *how*? It is unclear whether poor Ferguson (1) has seized the wrong day or (2), by seizing this day wrongly, has been responsible for its *becoming* a bad day.

VII

A Technical Question: Is Technology Ruining Humankind?

Artificial Intelligence, Naturalism, Functionalism, and the Concept of Self

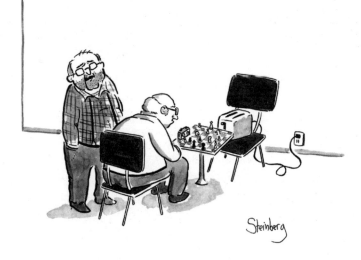

"I remember when you could only lose a chess game
to a supercomputer."

Ya Think It Thinks?

First off, a disclaimer: Our toasters could always beat us at chess. In fact, one of us was beaten in a hotel room in Indianapolis in 1962 by an empty suitcase. That said, cartoonist Avi Steinberg's rendering of the new generation of toasters has us wondering how they would have fared against Bobby Fischer or Garry Kasparov in their heyday. In fact, Steinberg's vision is not too crazy, given that the smartphone in your pocket has more computing power than NASA had at its disposal when it guided men to the moon in 1969.

The development of this level of nanotechnology is once again raising the old question: Can computers think? Often this question is asked out of anxiety: If computers can think, will they "replace" humans in some important, though as yet unimaginable, ways? This question is increasingly interesting to neuroscientists as they study how the human brain works and to philosophers as they try to understand what consciousness is.

One of the first to ask whether computers can think was Alan Turing, generally considered to be the principal inventor of

automated computing. Many of us know Turing from the movie *The Imitation Game*, in which we watch him virtually invent the computer from scratch in order to break the Nazis' Enigma code.

In 1950, Turing came up with what came to be called the "Turing test" to address the question of whether computers think. First, clear-eyed logician that he was, he narrowed the question. He said that because "thinking" is difficult to define, he would instead substitute the question "Are there imaginable digital computers which would do well in the 'imitation game'?"

The imitation game was a so-called thought experiment. Picture this, said Turing: In one room is a computer (participant 1); in another room is a person (participant 2); in a third room is another person (the evaluator). The computer would be programmed to generate humanlike responses, and a conversation would take place between the two participants. It would go something like this:

PARTICIPANT 1 (THE COMPUTER): So how's your wife doing? Still got that cold?

PARTICIPANT 2 (THE PERSON): She's much better, thanks. Lotsa colds going around.

PARTICIPANT 1: Tell me about it. I was in bed for a week with one.

The evaluator would know at the outset that one of the two participants was a computer and the other was a person, but he would not know which was which. If the evaluator could not tell from the conversation which participant was the person, the computer

would be said to pass the test. Think Apple's Siri or Amazon's Alexa, except way more sophisticated. Then consider that Turing dreamed this test up in 1950.

At the time, the Turing test was purely hypothetical; no computer in 1950 was even close to being capable of passing it. In 2014, however, a Russian computer program called Eugene Goostman simulated a thirteen-year-old Ukrainian boy. We understand that Eugene's conversation with the real person, Vladimir, went something like this (we're freely translating from the Russian here):

EUGENE: So how's your wife doing? Still got that cold?
VLAD: She's much better, thanks. Lotsa colds going around.
EUGENE: Tell me about it. I was in bed for a week with one.

Eugene fooled enough of the judges at the University of Reading in the UK that he was declared to have passed the Turing test.

Meanwhile, in 1980, John Searle had published his "Chinese room" thought experiment. Searle tried to get a little closer to the question "Do computers think?" But instead of the vague word "think," Searle questioned whether computers could be said to have a "mind" or "understanding" or "consciousness." Picture a computer, said Searle, that has been programmed to take input in Chinese characters, follow the instructions of its program, and produce output in Chinese characters. Suppose this computer does this so convincingly that an unsuspecting evaluator can't tell that it's not a person. It is tempting to think that the computer "understands Chinese."

Now put a real, live person in another room, a person who speaks English but does not speak or read Chinese. Give her a printout of the several thousand pages of instructions (in English) that make up the computer's program. These will include a complete set of Chinese characters and instructions in English on how to string them together to respond to various inputs (in Chinese characters) that will be passed through a slot in the door. She will do this—very slowly, mind you—totally manually by reading and applying the program instructions on the printout and handing the output back through the slot in the door.

So, can she be said to "understand Chinese"? Of course not. *Then neither can the computer*, says Searle. And if it can't "understand," then it can't be said to "think" or have a "mind" in any ordinary sense of those words.

Ergo, don't worry that your toaster can outthink you. Just remember, if it challenges you to a game of chess, you're always safe with the Ruy Lopez opening.

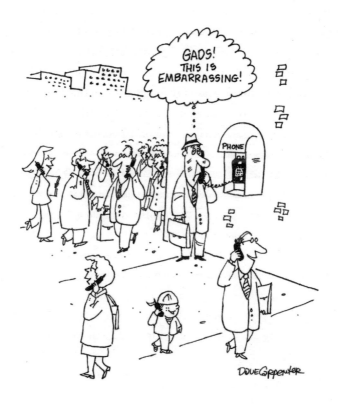

Lao's Tao of Techno

The guy in Dave Carpenter's cartoon appears embarrassed that he's out of sync with modern technology. But should he be embarrassed? Or should he read the *Tao Te Ching* to set him straight?

The ancient Chinese philosopher Lao-tzu was famously opposed to technology. Even in his day (around the sixth century BCE), Lao-tzu had had it with contemporary automation. He felt it alienated us from nature and our natural selves. In the *Tao Te Ching* (pronounced "Dao De Jing," sort of like a cash register ringing up a sale), of which Lao-tzu is the putative author, it says,

> Let there be labour-saving tools
> that aren't used.

The *Tao*, or Way, is the way of harmony with nature. To be in the Tao is to have achieved a state of *wu-wei*, meaning "nonaction" or "acting spontaneously" or "not forcing." Or, as we used to say in the '60s, "going with the flow, man." (Or at least some of us

used to say that; many of us weren't born yet, perhaps the ultimate state of *wu-wei*.)

> Therefore, the sage manages affairs without doing any-
>> thing, and
> conveys his instructions without the use of speech.

Got that? It's actually easier to explain without the use of words.

It is this hidden Way that brings about all things. It is the power (*te*) that creates all natural motion. Technological devices—even tools—are a distraction at best and a source of profound alienation at worst, because they are aimed at action rather than calmness, simplicity, humility, and the natural flow of things.

Lao-tzu has been inaccurately described as a Luddite, after the group of nineteenth-century workers in England who destroyed the weaving machines in textile factories. But the Luddites were not opposed to automation as such, only to that which threatened their livelihood, like automotive workers opposed to robots building Chevys. The word "Luddite" has in recent times, however, come to refer to anyone who opposes computerization or automation in general. Lao-tzu could relate.

The embarrassed man in Dave Carpenter's cartoon is feeling he has held out too long against the encroachment of digital technology. At first blush, it is hard to see why he would have felt that the pay phone was more "natural" than the smartphone, but

people in every generation often feel that way about the new. Even Lao-tzu seemed to be okay with using a cart. Today, some people apparently reject credit cards as being "plastic"—unreal—money, but they're not ready to go back to the barter system; paper money is *real*, after all. Maybe it's because "force of habit" feels "unforced," in Lao-tzu's sense.

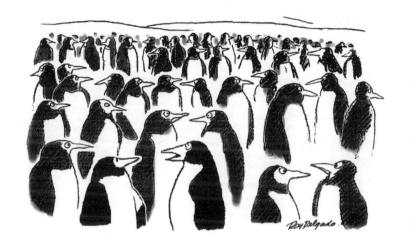

"I worry constantly about identity theft."

Where Do I Stop and You Begin?

One of the charges made against digital technology is that it is radically changing our sense of personal identity. So, what is this thing called identity? And what can these identical-looking penguins in Roy Delgado's classic cartoon tell us about identity?

In everyday life, it seems pretty clear what personal identity is—at least to "me." Like, "I am me, and you are you" pretty much does the trick. Among other things, this divvying up of identities is efficient, as in, "*I'll* do the dishes, if *you* clean the toilet." It is also useful in the business of ownership, as in, "This is my bank account, not yours. So, as a little precaution, *I* am not divulging my ATM PIN number to *you*. I hope *you* don't take it personally."

Nonetheless, the penguin in this delightful cartoon brings up a fascinating question about identity that became all the rage in the hands of the contemporary American philosopher Sydney Shoemaker and the recent British philosopher Derek Parfit. Employing their favourite form of argumentation, the thought experiment, Shoemaker summarily disposed of the idea that personal identity has anything to do with outward physicality.

Imagine, Shoemaker said, that two men, call them Mr. Brown and Mr. Robinson, undergo brain extraction during surgery for a brain tumour. Afterward, a careless intern sticks Brown's brain into Robinson's skull and vice versa. Only one patient survives, the one with Robinson's body and Brown's brain. For identification purposes, this hybrid is dubbed "Brownson."

Continues Shoemaker (as summarized by one of his students): "Upon regaining consciousness Brownson exhibits great shock and surprise at the appearance of his body. Then, upon seeing Brown's body, he exclaims incredulously, 'That's me lying there!' Pointing to himself he says, 'This isn't my body; the one over there is!' When asked his name he automatically replies, 'Brown.' He recognizes Brown's wife and family (whom Robinson had never met) and is able to describe in detail events in Brown's life, always describing them as events in his own life. Of Robinson's past life he evinces no knowledge at all. Over a period of time he is observed to display all of the personality traits, mannerisms, interests, likes and dislikes, and so on that had previously characterized Brown, and to act and talk in ways completely alien to the old Robinson."

Personal identity, then, is something in consciousness, not in outward form. Shoemaker's comrade-in-arms, Derek Parfit, says personal identity is simply "psychological continuity," all those memories, personality traits, TV miniseries favourites, etc., that make Brown *Brown*, in whatever body *he* happens to be residing. (We imagine any identical twin could have told us the same thing without either of them having to undergo surgery.) So Delgado's identical-looking penguins don't have to worry about

losing their individual psychological continuity, if that is what they are worrying about.

But then Parfit ups the identity ante by claiming that even this kind of personal identity is fluid. He proposes a thought experiment in which a woman named Jane agrees to have some of her friend Paul's brain cells inserted into her own brain. Afterward, Jane still identifies as Jane but has vivid recollections of a lovely visit to Venice, which, in fact, she never took. Paul, of course, did.

In any event, the penguin in question (his name, we found out, is Ralph P. Wadsworth III) is probably more concerned with a practical, nonsurgical form of identity theft, which is defined as "the fraudulent acquisition and use of a person's private identifying information, usually for financial gain." We have, of course, seen a huge and growing number of instances of this sort of identity theft, mainly because digital technology has made it so much easier. For questions about this sort of identity issue, we refer Ralph not to Sydney Shoemaker or Derek Parfit but to the US Department of Justice, Office for Victims of Crime.

Finally, one question about personal identity continues to perplex us: Do I really want to own my identity?

For an answer to this one, we turn to the eminent contemporary American thinker Heywood ("Woody") Allen, who said, "My one regret in life is that I am not someone else." Perhaps this was what he had in mind when he dropped his birth name, Allan Stewart Konigsberg.

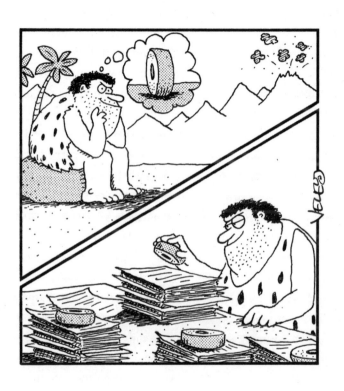

"Depends on How You Use It"

Some would say that the caveman in Bradford Veley's cartoon lacks imagination, a deficiency that could have cost human civilization millennia of progress had this guy really existed.

Yet, as so often is the case in philosophy—and cartoons— there is another way of looking at this, a POV that says this fellow is exceptionally imaginative. He is making technology our friend.

But first a little story: The other day a young man carrying a beer bottle asked to borrow our Bic cigarette lighter. We complied. The young man then turned the Bic around in his hand and used it to expertly flip open his beer bottle. Then he returned it.

"Ha!" we said. "And we thought it was a cigarette lighter."

"Depends on how you use it," the young man said, before guzzling down some Sam Adams.

He said a mouthful.

In the 1920s, the German American Gestalt psychologist Karl Duncker coined the term "functional fixedness" for a bias he discovered while studying human creativity. He said

functional fixedness is a "mental block against using an object in a new way that is required to solve a problem." Interestingly, the humans least likely to have this mental block are five years old and under.

At about the same time that Duncker came up with his notion of functional fixedness, the phenomenologist and existentialist philosopher Martin Heidegger wrote about his concept of "ready-to-hand" in his masterwork *Being and Time*. In this, he was countering the conventional notion that we, as subjects, see the world of objects detachedly, only in terms of their qualities—say, round, grey, and hard. Rather, Heidegger said, we are always engaged with the things we experience, always connected to them in a particular way. We use individual things in certain ways, think about them in terms of how we interact with them, and play with them in certain ways. We're part of the equation, not simply detached observers. In this mode of "being-in-the-world," objects are "ready-to-hand" rather than merely "present-at-hand," in Heidegger's lingo.

But the downside of relating to objects as ready-to-hand emerges when a new situation suddenly makes its readiness-to-hand irrelevant. Because we are always engaged with the objects we experience, we become blind to them. They're just another part of our world, like breathing or blinking. And in this way, we are oblivious to alternative uses of objects. A Bic lighter is simply part of our smoking experience, so we never think of using it to open a bottle of beer.

If this sounds a lot like Duncker's "functional fixedness," it's because it is.

Okay, back to our caveman. Maybe he never even considered using his imagined round stone thing for making a cart for carrying wood back to his cave (so he could invent fire). But let's just say he did, but that his more pressing need was to keep his utility bills from flying off his desk. So he used his round stone thing as a paperweight. No functional fixedness for him. He must have had the fertile imagination of a five-year-old.

VIII

Is There a Cosmic Scheme, and Who's Asking?

Cosmology and Other Metaphysics

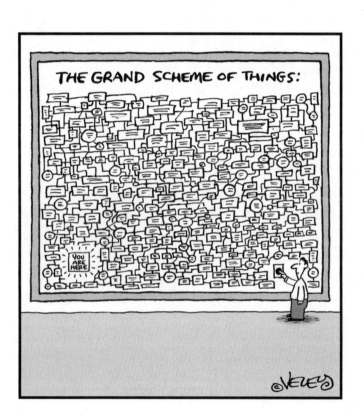

Nobody Here but Us Chickens

Bradford Veley here brings his philosophical acumen to bear on demonstrating one of the major turning points in the history of philosophy: the transition from the philosophy of Hegel to that of the existentialists.

Georg Wilhelm Friedrich Hegel was the most famous philosopher of his era, the early nineteenth century. Students came from all over Europe to hear him lecture on his eponymous Hegelian system. Through lectures and books, he expounded his view of nothing less than the totality of reality—the ultimate cosmic scheme.

Hegel's highly abstract philosophy centred on his notion that every individual thing and event is only partially real. Every state of affairs—whether in logic, art, politics, world history, or nature—contains within itself its own negation, which forces it to develop into something higher.

A concrete example: Hegel said that world history had evolved from despotism to aristocracy to constitutional monarchy. That was because the spirit of human freedom was gradually working itself out through the particular phases of history in a sort of

dialogue, or "dialectic." He saw this as a kind of conversation that reality has with itself, in which it realizes its own incompleteness and moves onward and upward.

Here's a pared-down version of Hegel's dialectic. If what he came up with for syntheses seem off-the-wall arbitrary, that's because he was looking *back* on how sociopolitical forces actually synthesized in history. Working backward, you can never be wrong, right?

So first, there's a thesis (despotism, where only the despot is free).

This is countered by an antithesis: "What do we want? More freedom! When do we want it? Now!"

This struggle yields a synthesis, aristocracy, where *some* are free.

Aristocracy has now become the new thesis (or status quo).

And it is countered in turn by a new antithesis: "You call aristocracy freedom? Not where we're standing, buddy, which is definitely not with the aristocracy. We want even *more* freedom! When do we want it? Again: Now!"

From this clash comes a new synthesis, constitutional monarchy, in which, according to Hegel, *all* are free. Could have fooled us with that one, Georg.

Hegel called the infinite end point of this dialectic—in ethics, art, political life, and everything else—Absolute Spirit. Some see "Absolute Spirit" as a code word for "God." Hegel considered himself a Christian, a view not always shared by other Christians.

Hegel thought he had uncovered the key to the universe. But several philosophers soon rebelled against Hegel's system. Karl

Marx liked the idea of the "dialectic" movement of history but said the "dialogue" was something much more down-to-earth, something more material than spiritual. It was actually the harsh class conflict between the exploiters and the exploited.

Another group of philosophers, the existentialists, took offence for another reason. Thinkers like Kierkegaard, Nietzsche, Heidegger, Sartre, and Camus said, in effect: "Hold on! You left something out: the individual! To exist, to be a genuine human being, isn't just a matter of consciously realizing what the whole system of reality looks like from up there. That's because we're down here. Our individual lives are here and now, and your grand scheme means next to nothing to us as we struggle to get through our lives, puny as they may look from up there."

Hegel's high-in-the-sky perspective was no help at all in figuring out what to do with our lives and how to give our lives meaning. We're way too busy trying to make decisions as finite individuals, decisions that involve risking everything we are and everything we might become. While Hegel is watching the Absolute Spirit gradually unfold history, we're trying to decide if our life would be better and more meaningful if we quit our job at the box factory and became missionaries in Venezuela. You're not going to get much help with that decision by understanding the dialectic of history. As Kierkegaard put it, "Life can only be understood backward, but it must be lived forward."

Existential risk is at the root of our anxieties, despair, and alienation. But also, happily, it is confronting existential risk that gives us a shot at what Sartre called an "authentic life"—a life of our own choosing, a life we can own.

Bradford Veley's cartoon cleverly depicts the tension between Hegel and the existentialists. On the one hand, he shows us the Hegelian grand scheme of things. It is complex, to say the least. On the other hand, he recognizes that his protagonist must push the button that lights up the existential "You Are Here." It's time for him to take charge of his life.

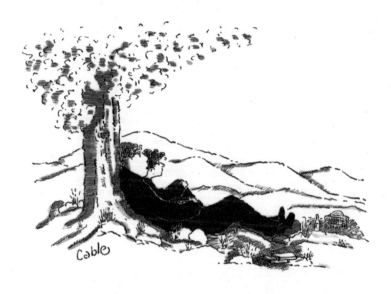

"I'd forgotten how non-textual nature could be."

Nature Naturing

The question that has philosophical cartoon scholars—both of us—in a tizzy these days is, "Does cartoonist Carole Cable believe that God exists in everything? Is she really, of all things, a pantheist?"

This is undoubtedly the same question you were just asking yourself.

Well, here's the evidence, pro and con:

The classic pantheist is the seventeenth-century Jewish Dutch philosopher Benedict de Spinoza. Spinoza famously spoke of God as *Deus sive Natura*, "God *or* Nature." By this he meant that God and the totality of Nature are one and the same thing. But by Nature, he didn't mean only the birds and the bees and such. He meant *all* of reality. And not just material stuff and living things either, but Thought as well.

God is everything there is, and everything there is, is God. (Somebody really ought to set that line to music.)

Spinoza found this view way more intellectually satisfying than the idea of a separate God who creates everything out of nothing. Apparently, Spinoza thought that if you're ultimately

going to have something that just *is* and *always has been*—something that itself has no cause—why not make it the whole of reality? Who needs one degree of separation between God and the universe?

Spinoza, like his contemporaries Descartes and Gottfried Wilhelm Leibniz, was a "rationalist," someone who believes all reliable knowledge comes only from inside our minds, not from "out there" in the world, as empiricists see it. So Spinoza's model of human knowledge was mathematics, not observation. For him, the actual birds and bees were just "modes of reality." Since there is only one substance, namely God, everything else—bodies, minds, telescopes, tea bags, the birds and the bees—is a *mode* of God or a "mode of reality." (Parents generally fail to stress this sufficiently when explaining the birds and the bees.)

The reclining young man in Ms. Cable's cartoon seems to be carried away with a much more naturalistic thought, one in which actual birds and bees are more important to him than their existence as modes of reality. So, thus far, this fellow doesn't seem to be a Spinozist.

On the other hand, Spinoza referred to the infinitely creative activity of God-or-Nature as *natura naturans*, or "nature naturing." And anything that was *already* created he called *natura naturata*, or "nature natured." It looks as if Cable's young man is really appreciating that spring is busting out all over—*natura naturans*, nature doing its naturing thing. So, by contrasting nature ablooming with the dead material of texts, Cable is clearly making a distinction between "nature

naturing" and "nature natured." Conclusion: She may be a Spinozist after all.

On top of that, Cable is suggesting that the overeducated young fellow in her cartoon has come perilously close to being "denatured" by reading too many philosophy books.

"Mr. Happy wants to remind us that tragedy plus time equals comedy."

Hallelujah, Come On, Get Happy!

Here we see the late, great *New Yorker* cartoonist Leo Cullum build his cartoon around a sly reference to G. W. Leibniz's "Monadology"! If you're looking for evidence that Cullum was the greatest American philosopher since William James, look no further.

The "Monadology" is Leibniz's eighteenth-century answer to the question of the grand scheme of the universe. Leibniz's "monads" are indivisible substances, which he thought were the building blocks of the universe. They are a sort of spooky version of atoms, except they're nonmaterial, so they can serve as the building blocks of souls and other nonmaterial things, as well as material objects. Each monad contains within itself its entire past as well as its entire future. Together, in accord with a harmony pre-established by God, they spin out the entire universe and everything that happens in it. Unlike atoms, though, they do this without any monad causing a reaction in any other monad. As Leibniz said, "They have no windows." They're all doing their own thing! It's like everyone is dancing to the music in their own heads,

but somehow together it's a dance number. Try thinking about that one after a couple of tokes.

Cullum's cartoon zeroes in on this "preestablished harmony." Why is it all so harmonious? Leibniz said it's because an infinitely good God could not have created it any other way. In fact, for that reason, it's the best of all *possible* worlds.

Now Cullum moves in for the coup de grace. At first he seems to be parodying the idea of a perfectly harmonious world. A member of the corporate Strategic Management Team and his sock puppet, Mr. Happy, are forecasting a rosy ending to a disastrous fiscal year. But in a final uplevel, Cullum signals that he knows full well that this sort of happy horse manure was the furthest thing from Leibniz's mind. Leibniz knew that some fiscal years are irredeemably disastrous. That'll happen sometimes in this best of all possible worlds. But in any other world it would be even worse, because a perfect God had no choice but to make the best world possible.

"No one designs for cat bodies."

Me, Me, Me

At first look at this cartoon, one might think that the gifted young cartoonist, Amy Hwang, was just composing a feminist gag about the problems of idealizing women's body types, but we are sure Hwang had a broader issue in mind: the problems of anthropocentrism.

In ancient Western philosophy and theology, the question of humankind's place in the cosmos was considered a no-brainer. Obviously, humans were at the *centre* of the cosmos. It all revolves around us. Indeed, it is all *for* us. Think about it: Who else could it all exist for? This POV is known as anthropocentrism.

The first chapter of Genesis makes this view of the grand scheme of things clear: "Then God said, 'Let us make humankind in our image, according to our likeness; and let them have dominion over the fish of the sea, and over the birds of the air, and over the cattle, and over all the wild animals of the earth, and over every creeping thing that creeps upon the earth.'"

Anthropocentrism (from the Greek, "man at the centre") has stayed with us over the millennia, although here and there some

thinkers found it, well, egocentric. In the twelfth century, the Jewish philosopher Moses Maimonides proposed a broader view of the cosmic situation. He wrote, "The individuals of the human species . . . are things of no value at all in comparison with the whole [of creation] that exists and endures." Take that, you anthropocentrists!

More locally, which is to say, here on Earth, Maimonides thought that placing humankind above other species was just plain condescending: "It should not be believed that all the beings exist for the sake of the existence of man. On the contrary, all the other beings too have been intended for their own sakes."

These days, animal rights activists are on board with Maimonides's anti-anthropocentrism. Peter Singer, the leading philosopher of the animal rights movement, makes the moral argument that any living thing that is sentient deserves the same rights as humans. Otherwise, we would be guilty of "speciesism," a new term that makes some people giggle, even some who are not anthropocentric. In leaving nonsentient creatures out in the cold, Singer parted ways with some of the more inclusive "deep ecologists" who believe one-celled creatures have rights too. Think about that next time you get a shot of penicillin.

"No, no—it was great. It's just that sometimes I'd like to try it missionary style."

It's All Relative, Honey

Cartoonist Mort Gerberg is playing here with the notion of erotic relativity. What "Daisy" (we've changed her name to protect her privacy) is expressing is that for her, as a dog, the missionary style is novel, exotic, perhaps even a tad devilish. We humans find this "cute." We're incapable of seeing that our laughter is hurtful and that we are being insensitive to the feelings of Daisy and her peer group. This is because we are stuck in our fixed notion that there is only one normal style and all other styles are novel or exotic only in comparison to it. In short, we are, as Maimonides said, pathetically people-centric.

What does this notion of erotic relativity have to do with the grand scheme of the universe? Admittedly, very little, unless you happen to have the kind of mind that sees the universe in a grain of sand or, in this case, that sees this individual case of relativity as a wee example of the grand relativity that underlies the operation of the entire universe. More's the pity, such are our minds.

Einstein demonstrated that relativity is at the very core of the way the universe works: All motion is relative to some particular frame of reference. It's no truer to say the earth "really" revolves

around the sun than it is to say that the sun "really" revolves around the earth or that they both "really" revolve around something else or around each other. It all depends on where you're looking from. In a word, it's all relative.

Einstein's theory carried the day with the scientists. But, as it turns out, the twentieth-century British philosopher Alfred North Whitehead had a competing theory of relativity.

Apparently, their differences revolved in part around their conceptions of the nature of space. Whitehead thought Einstein treated space as something substantive; for example, Einstein had said that space is curved. But in Whitehead's metaphysics, space isn't the sort of thing that is either curved or flat, because it's not the sort of thing that's a thing. Whitehead said the universe is better described in terms of *processes* rather than things. It seems that both theories predict the same phenomena and both leave some mysteries unaccounted for.

Arguing for one or the other is beyond our pay grade. In any case, we're betting that Daisy doesn't give a hoot. She knows what she knows, and from her frame of reference, the missionary position is looking good right now.

*"Would someone please remind me
what our original intention was?"*

We Are All, Like, So Evolved

Here's another relatively modern grand scheme of it all: Powered by the survival of the fittest, life is incrementally but ineluctably evolving toward perfection.

But first, a few words about Bradford Veley's cartoon. It made us laugh, although, when we thought about it, we weren't sure why. Or, for that matter, what exactly was going on in it. Why do the people hanging from the vines have briefcases, or partial briefcases, as it were? Why are the alligators wearing business attire? Did the people in the vines hire the alligators—maybe to pursue a more aggressive marketing strategy—and are now having second thoughts? Or is it as simple as the fact that the people originally intended to drain the swamp?

Then it came to us: Perhaps the "original intention" of the folks hanging from the vines was to save the alligator species from extinction via some benevolent ecological action. These right-thinking humans made sure the alligator habitat was cosy and their food supply plentiful, and maybe even threw in a simplified tutorial on how to use a computer to track fish. But what the people in the vines hadn't counted on was the alligators then

surpassing humans and taking the world over from them. In short, perhaps what the vine-hangers have discovered is that alligators have evolved to be potential businessmen and computer nerds. Up till now they've lacked only the opportunity. This was definitely not what the do-gooders had predicted. It was *not* their original intention.

If our theory is right, Bradford Veley's cartoon brings up a fascinating puzzle in the philosophy of science about Darwin's theory of evolution. To wit: Does Darwin's theory pass the all-important "falsifiability" test? And how does Darwin's theory do in terms of another crucial test for a valid scientific theory, the "predictability" test?

Let's start with the falsifiability test. In the 1930s, Karl Popper, an Austrian British philosopher, published *The Logic of Scientific Discovery*, in which he distinguished between genuine science and pseudoscience. He said a genuine scientific theory must *conceivably* be capable of being falsified. Say your theory is that no male crows incubate eggs. If there were a male crow that incubated, that theory would be proven wrong. That is what makes it a bona fide scientific theory. Popper stressed that he didn't mean there actually *had* to be such evidence—a real, live male crow incubating somewhere—just that such an incubating male crow, *if he existed*, would disprove the "no male crows incubate" hypothesis. When you think about it, Popper's falsifiability theory is very useful in thinking about many philosophical questions. Like if you said, "God physically exists, but nobody can perceive him," there wouldn't be any conceivable way to falsify that theory, so it would be a very hard sell as a scientific theory.

Some people, like creationists, say that Darwin's theory doesn't pass the falsifiability test. They say that any change seen in the fossil record is accepted as just "evolution in action," so no evidence could ever disprove the evolutionists' explanation of the generation of species.

Wrong, reply the evolutionists. All kinds of conceivable evidence could disprove Darwin's theory. Like evidence that mutations do not happen, or that mutations are not passed down from generation to generation, or that environmental changes do not promote survival of the fittest individuals or species.

Even Darwin himself anticipated the falsifiability test when he wrote, "If it could be demonstrated that any complex organ existed which could not possibly have been formed by numerous, successive, slight modifications, my theory would absolutely break down. But I can find out no such case."

Okay, but what about the objection that Darwin's theory cannot predict the future—like what humans will look like and be able to do in five thousand years? Theories in astronomy can do that; for instance, they can declare that Comet X will fly by the earth in the year 8025.

Actually, we need to think some more about that objection. We predict we'll have an answer for you in the year 7019.

IX

What Do You Mean, "Mean"?

Language, Truth, and Logic

"Pierre, I've never understood you; but, then,
I never was able to learn French."

How Do You Know
What You Can't Know?

What we have here in Hugh Brown's cartoon is a failure to communicate. Could philosophy be of any help?

By the middle of the twentieth century, nearly all philosophy in the English-speaking world consisted of analysis of language and logic. The era of analytic philosophy had begun. Many people say that philosophy can never be the same after this monumental development.

One reason for this megashift was philosophers' frustration with the fact that the classic big questions of philosophy (Does God exist? Do we have free will? What is the ultimate Good?) didn't seem to be answerable, at least not in a way that seemed certain or satisfying. Maybe, they said, we're asking the wrong questions. So they decided to analyse the language and logic at the root of these questions, because language and logic are at the root of all thought.

Philosophers such as Ludwig Wittgenstein and Bertrand Russell at Cambridge University, Willard Van Orman Quine at Harvard, and

several philosophers at Oxford began to address such sexy questions as the distinction between "the use of a word and its mention." It was at about this point that many of us started to long for the fuzzy questions and uncertain answers of yesteryear.

Still, one of Quine's contributions to analytic philosophy, the problem of "the indeterminacy of radical translation," turned out to be fascinating from both philosophical and anthropological points of view.

Here's how it works: Imagine a member of the Arunta tribe in the Australian outback, who, when he sees a rabbit, shouts, *"Gavagai!"* Now imagine an anthropologist who is trying to learn the Arunta language. "Egad!" he cries. (We have no idea why he employs the interjection "egad," considering that he was born in New Jersey in the late 1950s.) "What shall I write in my notebook? Does this tribesman mean, 'Hey, there's a rabbit!'? Or does he have a Platonic worldview in which everything we perceive is an instance of an ideal form, in which case he means, 'Rabbithood is manifesting itself there!'? Or does he have a relatively topsy-turvy worldview, in which case he means, 'By God, there are some undetached rabbit parts!'? Help!" our anthropologist goes on, "I'm at a loss for what to write!"

In Hugh Brown's cartoon interpretation of Quine, Pierre's wife (whom we will call "Patsy-Sue" to indicate her absence of Frenchness) had never been able to penetrate Pierre's world due to the indeterminacy of translation. To be honest, Patsy-Sue's problem wasn't *radical* translation, since English and French, unlike English and Arunta, have a great deal in common. In any case, Patsy-Sue doesn't know how to read Pierre's inscrutable look or

his conceivable words: *"Je t'adore, ma cherie."* Does he mean, "What are you crocheting?" Or is it, "That dress is simple but elegant"? Or possibly, "Why do you insist on calling me 'Pierre' when my name is Jacques?"

Such are the real-world problems caused by the indeterminacy of translation.

And some say philosophy isn't practical.

"I'm sorry, but the fact that your birth parents weren't married does appear to make you a rat bastard."

Watch Your Language!

It didn't take long for the analytic word philosophers to bump up against a problem that many people—if not anthropomorphic rodents—had been aware of all along: Language is rife with ambiguities.

Consider the profound levels of meaning in Peter Mueller's cartoon. First off, the man, who appears to be the adoptive father of the rat, is assuming that "You are a rat bastard" is a declarative sentence, comparable to "The cat is on the mat." In other words, Dad thinks he is just stating the facts as he sees them. But Junior may very well take his comment in a different, admittedly more painful, way. To sort this out, let's turn to the twentieth-century Austrian British analytic philosopher Ludwig Wittgenstein.

Wittgenstein's philosophy comes in two flavours, "early Wittgenstein" and "later Wittgenstein." To the early Wittgenstein, the sentence "The cat is on the mat" is a declarative sentence that gets its meaning from its correspondence to facts in the world. In other words, "The cat is on the mat" is true if and only if it is a fact that there is a particular cat sitting on a particular mat. (Honest, this is how analytic philosophers talk and what they talk about.)

Similarly, the adoptive father in our cartoon takes the sentence "You are a rat bastard" to be true if and only if you are a rat and you are a bastard. Since the rat is apparently both, the "truth conditions" of the sentence are met.

The "later Wittgenstein" more or less lost interest in declarative sentences (for what some may think are obvious reasons) and turned his attention to uses of language other than stating facts. He famously said, "In most cases, the meaning of a word is its use." To understand the meaning of most utterances, he said, you must adopt the conventions of a particular linguistic community. He called these conventions "language games."

In the linguistic community that most of us belong to, the conventional meaning of "You rat bastard!" is not, "You are a rat whose birth parents were unmarried!" It is something more like, "You're a real stinker!" (American), or "You're as thick as manure and only half as useful!" (Irish), or, our all-time favourite, "You're as ugly as a salad!" (Bulgarian).

Thus does philosophy illuminate our world.

"Assuming, of course, that a woodchuck
could chuck wood."

The Enlightened Tongue Twister

In their project of untwisting language, another problem for analytic philosophers was tugging out mistakes in reasoning, like the unwarranted acceptance of hidden assumptions. And the danger of accepting hidden assumptions is exactly what master cartoonist Aaron Bacall is alerting us to in this cartoon. Bacall's professor is proudly demonstrating to his colleague (identifiable by his pocket protector and mismatched trousers) his solution to the question of how much wood a woodchuck could chuck. The answer apparently is 1.2 cords. Belatedly, however, the professor has discovered his hidden assumption: that a woodchuck could, in point of fact, chuck wood.

Clearly, Bacall has read the contemporary Australian philosopher Alan Hájek, who put together a helpful list of what academics call "heuristics" (and what we call "rules of thumb"). When you're assessing someone else's argument, Hájek says, "See the word 'the' in neon lights." He's warning us that the word "the" can cover up a giant cesspool of hidden assumptions. For example, he says, the ethical question "What is the right thing to do?" assumes that there is *one* right thing to do, ruling out the possibility that

(1) there is no right thing to do and (2) there is more than one right thing to do.

An irony in the cartoon is that the assumption of woodchucks' wood-chucking capabilities has never really been hidden. Since childhood we have all known that the question of how much wood a woodchuck could chuck presupposes that a woodchuck could chuck *any* amount of wood, and, in fact, we always posed the question with that assumption explicitly set forth. Moreover, we intuited that the assumption of wood-chucking capability in woodchucks is a highly dubious assumption. That is why none of us has ever tried to derive an answer to the question of how much wood a woodchuck could, in fact, chuck. It is also why, despite the fact that the professor's derivation is salvaged by his exposure of his hidden assumption of woodchucks' wood-chucking abilities, we still think he may have a problem publishing his result in a peer-reviewed journal. On the other hand, you never know.

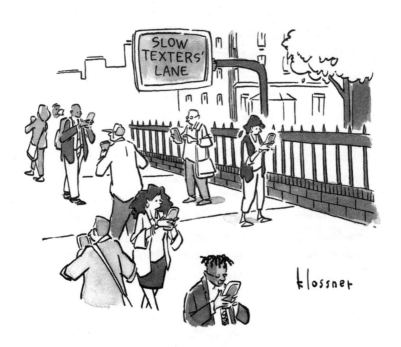

Confusion Ahead

Our guide to John Klossner's cartoon is the twentieth-century French philosopher Jacques Derrida. But unfortunately, Derrida confuses us to the point where we aren't sure if we really grasped what originally struck us as a perfectly understandable little pictorial gag.

Here's what we're up against in Jacques's own unmemorable words: "A text is not a text unless it hides from the first comer, from the first glance, the law of its composition and the rules of its game. A text remains, moreover, forever imperceptible. Its laws and rules are not, however, harboured in the inaccessibility of a secret; it is simply that they can never be booked, in the present, into anything that could rigorously be called a perception."

We definitely get his "forever imperceptible" part. We feel as if we must have read the preceding paragraph "through a glass darkly."

Fortunately, Derrida "explains": "Every sign, linguistic or non-linguistic, spoken or written (in the usual sense of this opposition), as a small or large unity, can be cited, put between quotation

marks; thereby it can break with every given context, and engender infinitely new contexts in an absolutely nonsaturable fashion."

Why do we feel as if we're still in the dark? Maybe we're too saturated.

Okay, let's try translating Derrida's quite extraordinary French into ordinary English. What we think Derrida means is that expressing an idea in a particular way attempts to stack the deck as to how it will be interpreted, but that attempt can never be totally successful.

Anyone who has ever written and then rewritten something can relate. Both the writing and the rewriting are intended to slant the communication toward what you *want* the reader to take away. But if the reader picks the text apart, word by word, phrase by phrase, alternate meanings emerge, and none of these meanings is "objective." Think of all those "misinterpreted" phone texts you sent to your significant other.

For example, suppose you send your S.O. the following text: "Honey, I won't be home till quite late. Feel free to eat without me." Maybe you foresee that he might read this as, "I wasn't really looking forward to eating with you tonight, and a better offer came along, so I took it." So you rewrite it to say, "I was really looking forward to eating with you tonight, but duty calls, and I can't make it." But he reads it as, "I'm going to tell you I was looking forward to eating with you so I won't piss you off, but I'd really rather do something else." Now suppose that a third person—say, a divorce lawyer—wants to make a case for what these messages "objectively" mean, and that that meaning is

grounds for divorce. But Derrida says they don't objectively mean anything. The texts are open to all those interpretations and dozens more.

But what about the text author's *intended* meaning? Wouldn't that be the correct interpretation of the message? Not necessarily, says Derrida. Words and phrases have possible meanings that the author may or may not have intended, or may or may not be aware that she intended. Think of our newfound sensitivity to the implications of gender pronouns. In the above scenario, our referring to the significant other as "he" is fraught with meanings for some people, meanings that we may believe we didn't intend.

Where does all this leave us? What's more, what do we mean by "Where does all this leave us?" We think we've been "correctly" interpreting Derrida. But what Derrida wrote is what he wrote, and our interpretation is only our interpretation. But, then again, so is his own interpretation of himself! Oh dear. You can see why Derrida drives some people to take up serious drinking.

But, hey, wasn't our linking this cartoon to this discussion based on a silly pun on the word "text" in the first place? Nope. A text on your phone is also a "text" in Derrida World, *n'est-ce pas?* In fact, Derrida would say that calling a phone text a "text" slants the reader's probable interpretation in a direction slightly different from calling it a "message" or a "salvo" or a "plea," a direction more neutral and more obviously opposed to a very different item that can be transmitted online, namely, an image.

Okay, we give in: The cartoon is *really* about people who text so slowly that they slow down traffic on the sidewalk. Or is it? That may be what Klossner intended, but so what? On the other hand, isn't that precisely what it means to "get" a joke or cartoon—to get what the author intended? Oh dear, our heads hurt. We have to go lie down.

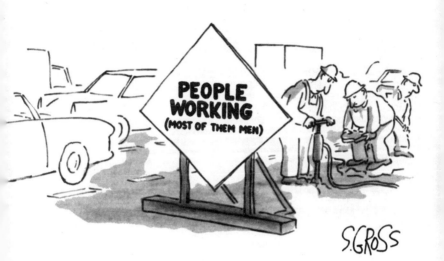

Do You Really Know What You're Talking About?

What is cartoonist Sam Gross up to in this little smiler? Is he merely taking a gentle jab at somebody's feeble attempt at a "politically correct" road sign?

Nope, he's up to way more than that. Gross is busy illuminating an entire postmodern interpretation of language.

It turned out that not only were assumptions hiding in some language, but entire worldviews and biases were tucked in there too. This became the pet peeve of the French semiotician and philosopher Roland Barthes.

Barthes looked at "signs and signifiers" (better known as words and phrases) through a lens of Marxist theory. There, he saw implicit, cultural bias in our everyday communication: notably, a bourgeois bias. For example, speaking and writing about wine in France generally suggests amicability, cosiness, and social cohesion, rather than, say, liver damage or drunken spousal abuse. Barthes felt that underlying most popular communication is what he called the "myths" of postwar consumer culture. The hidden

aim of public discourse is to maintain the status quo, to keep alive the "We're all doin' just fine" ethic. That way we won't even think about overthrowing the ruling class.

Sam Gross's cartoon shows a variation on a common road sign, "Men Working," with its bourgeois connotation of "any nonmen you see here are an aberration that we tolerate as long as it doesn't get out of hand," and translates it into a more radical (Barthes would say, Marxist) version, suggesting, "We are all people, supposedly all equal, and yet most of the jobs still go to men." More accurately, Gross *plays* with this distinction. We still think the sign looks funny, because, however enlightened we may be, one of our heads is still bourgeois: We know the sign is "supposed" to say "Men Working."

What Makes You Think You Know What You Think You Know?

Theories of Knowledge

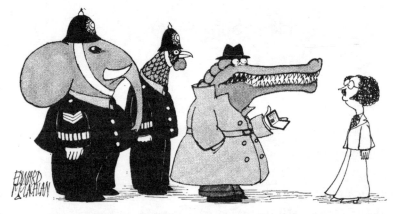

"We have reason to believe you are carrying certain substances of a hallucinogenic nature."

How Sure Are You?

Ed McLachlan's cartoon raises the perennial philosophical question of how certain we can be of our perceptions.

When René Descartes set out on his famous quest for certainty, his method was to subject all his beliefs to radical doubt. He said that if he could find any reason at all to doubt one of his beliefs, he would reject it as uncertain. And he would not rest until he had found at least one belief that could not be doubted. He figured that such a single certain belief would be a foundation on which he could build an entire system of knowledge.

Descartes thereby staked out his position as the first modern epistemologist. "Epistemology" literally means "theories of knowledge," and it involves asking questions like Descartes's: How can we be certain of anything? How can we tell the difference between knowledge and opinion? Between probability and certainty? Between illusion and reality?

He began by looking at his perceptions of the external world, and he quickly concluded that all these perceptions could be doubted away. For one thing, when he had vivid dreams, they all

seemed to be real at the time. So how could he be certain that he was not dreaming all the time?

For another thing, he could not rule out the possibility that an evil demon had planted a make-believe world in his mind. Later in philosophy, this scenario became known as the "brain in a vat" problem: How do I know I'm not just a brain in a vat, being fed faux sense data by a supercomputer?

For a capper, Descartes said, even if his perceptions of the world had been generally true up till now, who's to say for certain that an omnipotent but demonic God didn't change the world this morning, thereby making his beliefs false?

Note: If Descartes were alive today and offered the above list of mental doubts to a psychiatrist, the shrink probably would begin leafing through his copy of the *Diagnostic and Statistical Manual of Mental Disorders*, pausing somewhere in the section "Schizophrenia, Paranoid type." Well, maybe first he would ask René if he'd been nibbling on any mushrooms lately.

Cartoonist Ed McLachlan's 1960s drawing for the British magazine *Punch* adds another argument in support of Descartes's scepticism. The little hippie, identifiable by his bell-bottoms and granny glasses, has just been busted by what he takes to be a crocodile, a turkey, and an elephant in police garb. Even though most of us '60s survivors were aware that our perceptions were altered when we ingested magic mushrooms (psilocybin), there were many way-out-there types who thought that our mushroom-altered view of the world was the way the world would *really* look if we weren't so uptight all the time. This view was countered by politicians, parents, and appropriately dressed policemen, who

reminded us about acidheads who had jumped out of fourth-story windows in the belief that they could fly. Clearly, they implied, our ordinary, everyday belief in our limited natural aeronautic capabilities was the correct one.

Descartes did finally come up with a statement he considered certain: *Cogito ergo sum*, or, "I think; therefore, I am." Descartes thought the "cogito" was certain because, even if his prior beliefs were subject to legitimate doubt, it was undeniable that he had doubting thoughts about them, so there must be a thinker doing that doubting, whom he called "I."

We don't remember anyone who, while ingesting mushrooms, suddenly blurted out, "I think; therefore, I am!" much less, *"Cogito ergo sum!"* But, à la McLachlan's cartoon, we do remember one dazzle-eyed fellow warbling, "I am the walrus, goo goo g'joob, goo goo goo g'joob."

At the time, we knew exactly what he meant.

Beam It Down, Scotty

What cartoonist Mark Lynch is demonstrating here is the mind-boggling theory of knowledge of the British empiricist Bishop George Berkeley.

He is the philosopher who famously declared, *Esse est percipi*—"To be, is to be perceived." By this, Berkeley meant that so far as we can know, there is no chair "out there"; all we really know is that there is some chairlike sense data in our brains. It's enough to make the head spin.

Nonetheless, when we take a critical look at Berkeley's dictum, we realize it's not easy to argue with. We can't jump out from behind our senses to see that there is a substantive chair there "behind" our perceptions.

Well, then, where does that sense data of a chair come from? The good bishop had an answer for that: God conveys the sense data into our heads. God is omniscient, has an entire universe of information and data within his grasp, and can dole it out appropriately and coherently to each and every human mind. Zap! An entire world appears to us.

We can picture it: God behind his hallowed computer sending

sense data into our minds, creating the illusion that there's a chair "out there."

A famous cartoon by Peter Steiner has one dog telling another, "On the Internet, nobody knows you're a dog." On the Celestial Internet, no one except Bishop Berkeley, and, of course, God himself, knows who's pressing the keys.

"It is thornlike in appearance, but
I need to order a battery of tests."

Science in Action

Leo Cullum's mouse-physician is a particularly thorough practitioner of empiricism. Not content with basing the diagnosis of "thorn" on the thorny appearance of the foreign body, he wants to perform further empirical studies to confirm or disconfirm his initial observation. Perhaps he is influenced by the economics of fee-for-service medicine, in which more tests mean more billable items, but whatever his motive, he knows that unconditional empiricism is the way to go.

But this was not always so. Until empiricism ruled, many philosophers believed we could know all we needed to know by just thinking. For example, the English philosopher Henry More (1614–1687) thought that living bodies *must* contain some non-material forces to account for their complexity. He believed organisms just *have* to be more than simply mechanical parts humming along together; something else must be going on there—something that unifies and animates these bodies, like, say, a soul or a spirit. More arrived at this conclusion by thinking about it, working out the logic inside his bean. This marks him as

a rationalist, somebody who thinks that certain basic truths can be apprehended only a priori, that is, without recourse to observation. He believed these truths could be deduced by reason alone, preferably while sitting in one's study, smoking a pipe.

That kind of trust in a priori reasoning for positing facts and formulating theories about the external world was assigned to the dustbin of history by the eighteenth-century British empiricists, most eloquently by Scottish philosopher David Hume (1711–1776). Actually, this kind of rationalism was never completely discarded; it keeps making a comeback, as in today's anti-Darwinian arguments that maintain that random mutation and natural selection can't *possibly* account for the complexity of, say, eyeballs. ("Impossible" is a favourite word of the rationalists.)

Hume argued that we should "reject every system . . . however subtle or ingenious, which is not founded on fact and observation." While this may seem like common sense today, it got him in serious trouble as an "atheist and sceptic," and he was turned down for faculty positions at Edinburgh and Glasgow. In fact, he was never able to secure an academic post anywhere.

One of Hume's revolutionary ideas was that we could base all the other sciences on the scientific study of human nature. Why human nature? Because all other knowledge depends on understanding what kinds of questions our minds are capable of answering and what kinds of questions are beyond our capacity. The questions we are equipped to handle are those that can be answered by empirical observation rather than a priori speculation. Therefore, Hume is known as an epistemologist, that is, one

who examines sceptically how we can know what we purport to know, and an empiricist, one who concludes that our only path to understanding the external world lies in experiment and observation. His work was inspired in part by the great natural scientists, particularly Isaac Newton, and Hume in turn inspired the further development of the scientific revolution.

That said, we still think we know a thorn when we see one. Yank it, doc!

"Snow again, today . . ."

Ring-a-Ding-Ding

What we have here is cartoonist Dave Carpenter's metaphor for Immanuel Kant's distinction between "phenomena" and "noumena." Phenomena are things "as known through the senses"—the combination of sights, sounds, smells, tastes, and touch sensations that appears in our minds when we encounter a particular object. Call them appearances. But appearances differ from one moment to the next and from one observer to the next, so Kant invented the word "noumenon" to signify what it is that lies behind all the appearances, the underlying reality that is the source of all the various appearances of an object.

We "know through the senses," for example, that a certain chair is red. But, as Berkeley pointed out, all we really know is that the chair *appears* red to us. That's because our knowledge of this attribute of the chair is received through our eyes. Perhaps to different light-sensitive organs—the eyes of a mackerel, say, or the antennae of a Klingon—it appears completely different. In the case of the mackerel, maybe it appears gold or striped. In the case of the alien, maybe it appears *sqarzinated*, or even

dzztollerine (two Klingon words, totally untranslatable, because we and the Klingons have totally different experiences that the words refer to).

But wait, it gets even more mind-boggling, as Kant takes it a step further. He asks how we would describe the chair as it is *in itself*, "behind" our experiences of it. In other words, what can be said about this "something-or-other," this noumenon, that appears red to us and *sqarzinated* to others? What's it "really like"? We can't know, says Kant, because all our words for what something "is like" are taken from the world of appearances. We have no way of knowing *anything* about the chair-as-it-is-in-itself.

As Berkeley argued, we can't slip out from behind our senses and their perceptions and "know" the chair in some other way. Kant therefore says the noumenon, or thing-in-itself (*Ding an sich*), is "equal to *x*."

That's not a whole lot of help, Immanuel. Yet, in contrast to Berkeley, Kant says we know the *Ding an sich* is "out there" in some sense, because we and the Klingons both experience it. But that's all we know.

Mr. Carpenter's weatherman lives inside a snow globe, and it would appear that he can't see outside of it. The world as it appears to him is a world of perpetual snow. He has no idea that from our point of view, he appears to be inside a snow globe. Not only that, but he also has no idea that out here, it looks cloudy with intermittent sunshine. But in the end, we are no different from the encapsulated weatherman. Our viewpoint is limited too. If we could look from the world of things-in-themselves, we would see

that our point of view is as restricted as his. We also live in a snow globe of appearances. We only *think* we are seeing the world as it "really is."

If you nodded your head enthusiastically, you are either philosophically minded or have serious mental issues, although some would say this is a distinction without a difference. In either event, we recommend against having the following conversation with your significant other.

s.o.: Oh, look, hon! The sky is totally pink tonight!

YOU: Well, it *appears* pink.

s.o.: That's what I said.

YOU: No, you didn't. You said it *is* pink.

s.o.: Right. Pink is the colour of the sky.

YOU (SOMEWHAT CONDESCENDINGLY): How can you say that? You don't know that. All you know is that it *looks* pink!

s.o.: Are you saying that it's really a sort of pale cerise?

YOU: No! I'm saying you don't know that it's *any* colour.

s.o.: And you do know, I suppose!

YOU: No! I'm saying *neither* of us really knows.

s.o.: Oh, and who does know? Your new secretary, I suppose!

YOU: What? You think Elaine lives in the world of the *Ding an sich*?

s.o.: I think you live in the world of the ding-dong! I'm going in and watching Rachel Maddow.

*"Will you please tell the rest of the class
the process you used to arrive at your answer?"*

You Say Analytic, I Say Synthetic, Let's Call the Whole Thing Off

What cartoonist Aaron Bacall's first-grade teacher is really asking her young student to explain is his solution to the classic dilemma: Are the truths of mathematics *analytic* or *synthetic*?

Of course, there's a wee chance that the teacher doesn't realize the full extent of her question, but she probably has an inkling. And it turns out that a lot of tricky philosophical questions start with such inklings.

To dig into this question, we need to go way back to a distinction made by Immanuel Kant in his major work the *Critique of Pure Reason*.

Kant said that there are two kinds of statements that can convey knowledge. The first he called "analytic." These are statements that are *true by definition*: for example, "All orchids are plants." This is true because if an object is not a plant, it can't possibly be an orchid, no matter how pretty it looks pinned to the shoulder strap of your ball gown. Kant said we know the

statement "All orchids are plants" is true a priori, or *prior* to experience. It's true by definition. We don't need a botanist, or even our own observations, to know that it is true. Even if you've never seen an orchid, you can know the statement "All orchids are plants" is true—that is, if you know the English language and have the word "orchid" in your vocabulary. Weirdly, it would be true even if there were no such thing as an orchid, because all the statement really says is that if anything *is* an orchid, then it's a plant, because planthood is part of the definition of "orchid." No planthood, no orchid.

The other kind of statement that can convey knowledge Kant called "synthetic." By this he meant that these statements convey knowledge of the world rather than just knowledge of the definitions of words. Most of the statements we make every day are synthetic: "Orchid blossoms are up to six inches in diameter." Kant said such statements are generally known a posteriori, or *after* experience or observation. It would be impossible to know without someone's having observed actual orchids whether the statement about its diameter is true or false. That's because size, unlike planthood, isn't part of the definition of "orchid."

Philosophers have puzzled for eons over whether the truths of mathematics are analytic or synthetic. The teacher would like her student to explain to the class how he came to know that $1 + 1 = 2$ (other than the fact that he just memorized this equation). This may seem a bit unfair to a first-grade student. We strongly suspect that it may stem from the fact that the teacher herself has wrestled with the problem to no avail and is

now using the old pedagogical trick, "When you yourself do not know the answer, ask the class, 'What do *you* think?'"

What the student is probably thinking is something like this: "On the face of it, '1 + 1 = 2' would not seem to be synthetic. I did not arrive at this answer by observing that every time I have brought one object together with another, I ended up with two objects. Nor do I think it's likely that mathematicians down through the ages, whose work I am building on here, arrived at it in this way. So, I guess mathematical truths are analytic, as philosophers Gottlob Frege, Bertrand Russell, and Ludwig Wittgenstein said. But that would involve coming up with proper definitions of 'number,' 'plus,' and many other basic mathematical terms. Whew, there goes the bell. *Recess!*"

What's the Best Way to Organize Society, and What's in It for Me?

Social and Political Philosophy

"We can't come to an agreement about how to fix your car, Mr. Simons. Sometimes that's the way things happen in a democracy."

Let's Take a Vote on Getting Rid of Democracy

J. B. Handelsman's cartoon does a regular *reductio ad absurdum* job on the way democracy works—or, rather, doesn't work. In case you haven't noticed, democracy can be messy. Between feuds and compromises, hardly anyone can get what they really want, or worse, nothing gets done at all. But are there any viable alternatives?

The magnificent Hellenic philosopher Plato thought so. He would have told the auto mechanics in J. B. Handelsman's cartoon that what they clearly need is a philosopher king, Plato's favourite type of ruler for his favourite form of government. This would be an individual educated from youth in the Forms, or Ideas, of wisdom and virtue. And cars.

Plato famously distrusted the democracy of the Athenian city-state. Who can blame him? They had, after all, arrested his mentor, Socrates, for teaching the youth of Athens to "question authority!" and then executed Socrates by forcing him to drink

hemlock. (Socrates, a bit of a wag, asked his executioners if he could first pour out a libation to the gods.)

Plato thought democracy was a flawed form of government. Because its organizing principle is freedom of the individual, democracy makes the equal and the unequal *equal*! *Really! What PC drivel!* The superior individual is reduced to the level of everyone else. Everybody does his or her own thing. As a result, anarchy ultimately reigns, not only in the state but in the home, where the son is on the same level with his father and has "no respect or reverence for either of his parents." Similarly, scholars disrespect their tutors and actually compete with them. The old condescend to the young and adopt their manners, so they won't be thought morose. Imagine!

Eventually, says Plato, some rise to greater power than the rest, because they are clever at outfoxing everyone else in this dog-eat-dog world. Then the people turn to a strongman who promises to protect the lower classes from the establishment, and democracy turns to tyranny. Not good at all.

Unfortunately, there is one small detail missing from Plato's alternative to democratic rule. He never adequately explained how the philosopher kings get chosen. Details, details. Somehow, a perfect SAT score seems inadequate. But in Handelsman's garage, a long record of perfectly functioning cars might be a good start.

It's Only Natural

Here's a cartoon from Lee Lorenz that smacks some major philosophical questions right in the kisser: What are the laws of nature? How can we figure out what they are? And, most important, how do they apply to the moral and political principles of human beings?

In Western civilization, philosophers have been talking about natural law for millennia, going back to Cicero in ancient Rome, popping up in the Middle Ages with Thomas Aquinas, and developed later by Thomas Hobbes, John Locke, and Jean-Jacques Rousseau. Natural law even shows up in the American Declaration of Independence, which declares that the American people should accept "the separate and equal station to which the Laws of Nature and of Nature's God entitle them."

The basic idea of natural law philosophy is that human morality can be deduced from basic human nature, because it was put there by the Divine Designer of the Natural World. Further, we can figure out exactly what these laws are and how they apply to us through reason and analysis.

Thomas Hobbes distinguished between natural law and the "state of nature," and saw them in irrevocable conflict. Hobbes thought the natural state of humankind—before governments and civilization—was "nasty, brutish, and short" and that the natural law for humans was to not do anything destructive to their own lives. That meant getting as far away as possible from the "state of nature" and giving over our personal sovereignty to the sovereignty of an authoritarian state.

John Locke, on the other hand, felt that the state of nature had been generally peaceful, and that the natural law of reason taught that no one ought to harm another person in his life, liberty, or property. Nonetheless, this state was insecure, because, guess what, not everyone obeyed the law of nature. Since he had a rosier view than Hobbes of humanity's natural state, Locke thought that limited, constitutional government was capable of maintaining peace and security. That's why Locke is seen as one of the forefathers of American democracy.

We must admit, though, that our emotional favourite natural law philosopher is the eighteenth-century Genevan social and political philosopher Jean-Jacques Rousseau, who had an even more benign view of the state of nature. He asks us to drive right into that jungle and take a good look around, especially at savage man, because savages are in possession of uncorrupted morals—uncorrupted by such things as kings and landowners and CEOs and reality TV.

Wrote Rousseau: "Nothing is so gentle as man in his primitive state, when placed by nature at an equal distance from the stupidity of brutes and the fatal enlightenment of civil man."

In particular, he preferred the way savages lived to the way civilized men and women did because they were not yet self-centred or corrupted by what he called "the petulant activity of our egocentrism."

"The more one reflects on it," Rousseau wrote, "the more one finds that this state was the least subject to upheavals and the best for man. . . . The example of savages . . . seems to confirm that the human race had been made to remain in it always; that this state is the veritable youth of the world; and that all the subsequent progress has been in appearance so many steps toward the perfection of the individual, and in fact toward the decay of the species."

So where does *New Yorker* cartoonist Lee Lorenz come down? His sly reference to the common expression "law of the jungle" suggests he may be a Hobbesian, envisioning a dog-eat-dog world of wild animals and brutal humans. As Willy Loman's brother Ben in *Death of a Salesman* says, "When I was seventeen I walked into the jungle, and when I was twenty-one, I walked out, and, by God, I was rich."

But a good case could also be made that the gentle language of the sign marks Lorenz as a Rousseau man.

We're going with the latter. We're going in there, Lorenz. But it would be kinda nice if you would airdrop in a civilized meal of burgers and fries now and then.

"I don't have to be a team player,
Crawford. I'm the team owner."

Power Up

When it comes to organizing his little society, cartoonist Leo Cullum's team owner is clearly of the Machiavellian/Nietzschean persuasion. No team player is he. For him, individual power—his own—is the best way to go.

When it comes to the question "What is the best way to organize society?" it always comes down to the question of power: Who has it? Who doesn't? How do you get it? How can it be constrained?

Philosophers down through the centuries have had wide-ranging attitudes toward power. Plato thought it should be vested in philosophers, a self-serving belief if there ever was one. (Personally, we think cartoon analysts should be in charge. It seems self-evident to us.) The virtue of the warrior class, Plato said, is courage, but the virtue required of the leaders, or "guardians," of society is wisdom. This is why society should be ruled by philosopher kings.

Epicurus recommended dropping out of politics altogether in favour of pursuing the quiet pleasures of life. Tend your garden, and leave the world to tend itself, he said.

Machiavelli leaned toward the authoritarian exercise of power. He said, "A prince who wishes to maintain his power ought therefore to learn that he should not be always good, and must use that knowledge as circumstances and the exigencies of his own affairs may seem to require."

In more recent times, Friedrich Nietzsche affirmed our "*will* to power," saying that self-affirmation is healthy and noble and that the superior man is entitled to exert his power over the common herd.

In the twentieth century, French thinker Michel Foucault saw power everywhere, not just in political structures. He said power relations are even at the base of what it is permissible to think. For example, as our attitudes toward transgender individuals shift, various formal and informal power groups, such as schools and peer groups, try to regulate our attitudes one way or the other.

Who Are You to Question Authority?

*The Philosophy of Law
and Moral Authority*

"Aren't you being a little arrogant, son?
Here's Lieutenant Colonel Farrington, Major Stark,
Captain Truelove, Lieutenant Castle, and myself,
all older and more experienced than you,
and we think the war is very moral."

Does Mother Know Best?

Holy Toledo, here is a cartoon by J. B. Handelsman that critiques the argument from authority without a scintilla of irony. How'd he do that?

The argument from authority states that something is true or morally correct because a bona fide expert endorses it. We are sure that the world is round because Pythagoras said it was, and Pythagoras was renowned as a very wise man. In fact, because Pythagoras gave us this information, we don't have to bother ourselves with doing any complicated geometric calculations to figure out that the world is round. Pythagoras did all that so that we didn't have to.

What's more, we are sure that it is wrong to draw crayon pictures on the living room wall, because our mothers said so, and, when it came to proper behaviour, our mothers were experts. (They also had considerable clout around the house, but that's another story.)

Many philosophers have urged us to be cautious about buying into the argument from authority because, in the wrong hands, this argument can be used to misinform or, worse, control us.

Among these philosophers was the seventeenth-century British philosopher John Locke, who issued a strong warning against those who uncritically accept the argument from authority. He cautioned us that expert testimony can be misused by leveraging people's respect for authorities to add weight to ideas that might otherwise not seem so obvious or that might even be false.

Later on, some logicians began to refer to the argument as the "*fallacy* of the argument from authority," but it is not a fallacy in the strict sense, the way, say, circular reasoning is a logical fallacy. Often the argument is perfectly appropriate, just not definitive. For those of us who have not directly measured the data of climate change and don't have a clue of how to do so, it really is a strong argument to cite the 98 percent of climate scientists who say that it is both real and at least partially man-made.

But some cases are a little greyer, and there is nothing like a political cartoon for capturing greyness. J. B. Handelsman's cartoon was published in 1968, at the height of the war in Vietnam. It is conceivable that the officers at the table might have some limited factual knowledge about the conduct of the war that could help someone decide what to make of the morality of it. But to cite their authority as military officers as the source of their moral judgment is so obviously questionable that Handelsman knew he could get a wry and somewhat pained laugh out of it.

But wait! Handelsman may also be making a backdoor appeal to Saint Thomas Aquinas's "just war" theory, which was often cited during debates about the morality of the Vietnam War. Thomas said that, in order to be just, a war must meet three criteria:

First, the war must be declared by a sovereign rather than a private individual. There was, in fact, much controversy early on about the fact that the war had not been declared by Congress as required by the US Constitution.

But the debate really turned on Thomas's second and third criteria. His second criterion was that war should be waged only for a "just cause"—that is, because those who are attacked "deserve it on account of some fault," such as having seized property or treasure unjustly and refusing to give it back.

The third criterion, said Thomas, is that the attackers must have a "right intention" to advance good or avoid evil, rather than acting out of vengeance or cruelty or aggrandizement.

So the soldier in Handelsman's cartoon may be protesting the war based on Thomas's criteria. It's less clear what theory Lieutenant Colonel Farrington, Major Stark, Captain Truelove, Lieutenant Castle, and the general may be employing.

Wow! Handelsman really is a philosophical genius.

"Advantage, Mulloway."

Because I Said So—That's Why

Okay, we admit it: Michael Maslin's cartoon gives us the willies. It strikes awfully close to news stories we've been reading about goings-on both hither and yon. It seems that Machiavellianism is flourishing.

One of the most appealing aspects of the governing principles laid out by the sixteenth-century Italian philosopher Niccolò Machiavelli is their sheer simplicity. For a prince, an act is right if it is helpful in his acquiring or maintaining his power. End of story.

In a way, this is the argument from authority taken to the highest power. The people don't obey the prince because he's an expert. They obey him because any disagreement with him would be at their peril.

This allowed Machiavelli to make such counterintuitive pronouncements as "the end justifies the means." Wrote Machiavelli in the *Discourses*, "For although the act condemns the doer, the end may justify him."

And if that needs any clarification, in a letter to Piero Soderini, he said, "In judging policies, we should consider the results that

have been achieved through them, rather than the means by which they have been executed."

Put this together with Machiavelli's approval of the prince's desired "end" of maintaining his own power, and you have what most people would say is immoral moral philosophy. To a prince, self-glorification is a necessary virtue, and warfare as a means to that end is therefore justifiable. For the prince, might is right, and all the rest—like, say, the Golden Rule—is self-defeating baloney. Got it? *You'd better!*

Understandably, many high-minded types, like bishops and saints, claimed that this wasn't moral philosophy at all. It was devil talk.

In veteran cartoonist Michael Maslin's cartoon, not only is sharpshooter Mulloway clearly a Machiavellian; so is the announcer. Incidentally, Maslin is married to another *New Yorker* cartoonist, Liza Donnelly. Rumour has it that they steal ideas from each other. Just because they can.

XIII

Who Says I'm Responsible?

Determinism, Free Will,
and Existentialism

"Once it became clear to me that, by responding correctly to certain stimuli, I could get all the bananas I wanted, getting this job was a pushover."

The Stimulus Made Me Do It

In this cartoon, the prolific Jack Ziegler plays a heady head game with the free-will-vs.-determinism conundrum. His executive monkey gleefully admits that he's ruled by a stimulus-response/cause-and-effect universe. And such a universe would seem to be absolutely deterministic. Yet Ziegler's monkey has figured out how to manipulate that system to his own advantage. How'd he do that? And what does this tell us about personal responsibility?

If there's no such thing as free will, we don't even have authority over ourselves. If everything we do is determined beforehand by, say, the perpetual cycle of stimulus and response, then trying to come up with a principle for moral decisions is futile. Everything will happen the way it's programmed to happen, including our so-called decisions.

The whole free-will-vs.-determinism debate has been raging ever since philosophers decided—or *thought* they decided—it was a fundamental question. Beginning in the twentieth century, the debate moved onto a decidedly psychological and scientific path. With his concept of "radical behaviourism," the celebrated Harvard psychologist and philosopher of science B. F. Skinner

declared that *all* human behaviour is the result of conditioning. Everything we do comes down to our responses to the rewards and punishments that impinge on us. In the final analysis, we are no different from the pigeons Skinner trained to peck on a button by rewarding them with a bit of food when they did. Well, except for our being featherless.

Wrote Skinner: "By questioning the control exercised by autonomous man and demonstrating the control exercised by the environment, a science of behaviour also seems to question dignity or worth." He says this not as a put-down but just as a fact.

Of course, this raises the question of what a person is to do if he knows he has no free will. Just sit there and wait to see what happens to him?

No, says Skinner. We just have to learn how to control the environment that controls us.

It's about there that he loses us, although it doesn't sound any wackier than the more philosophically sophisticated William James's statement that his first act of free will is to believe in free will.

Kant said the arguments for both free will and determinism boil down to the fact that imagining the opposite is too weird. If we try to picture being totally determined, we're stumped by the question of what we're supposed to do with that information other than lie down. (And even lying down wouldn't count as a free choice. The universe would have made us do it.) On the other hand, if we try to imagine performing an undetermined free act, we have to ask how that would differ from a totally random act.

Ah, philosophy—always better at the questions than the answers. But the questions are so much fun, eh?

In any event, cartoonist Ziegler hits Skinner's thesis on the head. Being good at the stimulus-response game is the way to get ahead in this world . . . whatever kind of animal you are.

"That's the last time I take responsibility
for my own actions."

Don't Tell Me I'm Not to Blame!

Did the cartoonist Rex May (nom de plume, Baloo) know that his incarcerated character was actually challenging the very foundation of twentieth-century existentialism? And, more important, does May take full responsibility for his provocative stand?

In his 1946 lecture "L'existentialisme est un humanisme," the celebrated French existentialist Jean-Paul Sartre answered a serious challenge from his critics. Sartre had said that there is absolutely no transcendent ethical standard. As an atheist, he obviously ruled out the usual suspect, the Transcendent Standard-Setter (a.k.a. God). But Sartre also claimed that most humanists, who claim to eliminate God from the equation, essentially let him in the back door by claiming that there are nonetheless objective standards of morality that are binding on all people. Wrong! said Sartre. "Our existence precedes our essence." We are free to create our own essence, our own morality, our own standards. The only absolute moral rule is: Don't give away that freedom by clinging to some imagined objective standard.

Sartre's critics charged that he was basically saying that we can do anything we want, and, therefore, we have no responsibility for our actions. *Au contraire*, said Sartre. We have *more* responsibility. Instead of clinging to some objective ethical principles, our freedom to create our own standards makes us *absolutely* responsible for our choices. Our freedom puts *us* in the place reserved by most people for God.

Does that mean it's every person for him- or herself? Do I have to accept everybody's moral standard as equally valid? As valid as, say, mine? No, said Sartre. When I choose, I am choosing the best way for *all* people to live. Hmm. So, J-P, what's the criterion already? Here Jean-Paul gets a little vague and says that creating your life is like creating a work of art, as opposed to just copying someone else's. It's not that artists don't make mistakes. They do. And it's not that some of their choices aren't better than others. They are. But in the end, the work of art is a result of *their* exercise of freedom, and they must take responsibility for it. So it is with creating our own morality.

It is here that Baloo reveals his Sartrean ethic. Our jailbird is ignoring Sartre's insistence on personal accountability. He is announcing that from now on he will no longer be taking responsibility for his choices. We doubt that this is because he will be adopting some transcendent standard or giving his life to God. More likely, he just plans to do what he wants and not worry about it. Sartre would be pleased—about the God part. The lack of responsibility, not so much.

XIV

What Went Wrong with Right and Wrong?

The Philosophy of Ethical Behaviour

"Your duties will be simple, Wilkins—pass the bottle
when I get dry and brush away the blue-tail fly."

Do the Right Thing, Whatever That Means

What we have here in Leo Cullum's cartoon is a perfect illustration of deontological ethics ("duty ethics"). Deontologists depict ethics as a system of rules that lays out our duties to one another.

For example, the Ten Commandments is a list of eternal duties, based on "divine authority." The Declaration of Independence outlines a number of "God-given" rights that imply certain duties incumbent on any government. The Catholic Church declares that one has a duty, grounded in "divine and natural law," to refrain from euthanasia, abortion, and homosexual acts, among other things.

Alternative ethical theories include utilitarianism (what is good is whatever results in the greatest utility, or happiness, for the greatest number) and virtue ethics (in which good is behaviour that both stems from and contributes to the development of excellence of character).

Clearly, the boss here is laying down a deontological ethic. The

duties in the job description are two: (1) pass the bottle when I get dry; (2) brush away the blue-tail fly. The boss doesn't want his new hire making any judgments about whether passing the bottle or brushing away the fly will bring about maximal happiness, either for the boss, the fly, or anyone else. Nor does he care what the employee's motive is or whether he will develop an excellent character. His only interest is in the availability of the bottle and the absence of the blue-tail fly.

Before we leave Wilkins and his employer, we want to add a word about the song "Blue Tail Fly" (a.k.a. "Jimmy Crack Corn") from which the line "Pass him the bottle when he got dry / And brush away the blue tail fly" comes. It was originally a slave song about doing the bidding of the master; in other words, deontological ethics at its most abhorrent. Could it be that Mr. Cullum had issues weightier than a dumb boss on his mind when he created this cartoon?

*"Have you ever considered the possibility that
I don't want the paper?"*

Getting Down to Basics

Here again, the ethical philosopher and master cartoonist Leo Cullum raises a significant question in deontological ethics: How do we go about discerning basic, universal moral principles, when individual people are so different from one another? How do we apply these principles when one man's meat is another man's poison?

Immanuel Kant's supreme categorical imperative was his attempt at formulating a *universal* moral principle—one that would apply to *every* conscious being (including, conceivably, highly precocious dogs). However, as Cullum illustrates, this can get tricky because of the different-strokes-for-different-folks problem.

The basic formulation of the categorical imperative is: "Act only according to that maxim whereby you can, at the same time, will that it should become a universal law." This has a decidedly Golden Rule ring to it: We should do things based on only moral principles to which we believe everyone should adhere. For example, if I'm considering whether I should live by the maxim "An eye for an eye," I must come to terms with Martin Luther

King's warning that, as a universal law, that would leave everybody blind, including me.

Our sweet dog knows from cultural experience that good doggies bring newspapers to their masters, and so he resolves to live by the maxim "When your master is in his armchair, always fetch him the paper!" In fact, he believes that this is a universal principle for good dog behaviour. Sounds like pure altruism, right? What could possibly be wrong with that?

Well, it turns out that this particular master apparently gets all the news he wants on his iPhone. Sometimes it's hard for a good doggie to keep up with the times.

"Eureka! After months of research and formulating algorithms, I've done it . . . I've discovered the secret to 'being cool'!"

The "You" Calculus

One solution to the individual-differences problem that confounded the newspaper-bearing dog in Leo Cullum's cartoon was offered by utilitarian philosopher Jeremy Bentham. In creating the greatest good for the greatest number, Bentham said that we could assess, catalog, and apply a numerical value to individual differences and then distribute the "goods" accordingly. One person adores pistachio ice cream; another can't live without knitted mittens. We can work it out equally and fairly once we've assembled all the data.

And this is where the cartoonist Mark Godfrey (a.k.a. NAD) comes to our aid with a wacky cartoon to help us understand Bentham's wacky calculus for sorting out individual pleasure preferences. NAD's mad professor has worked out a Byzantine formula for "being cool," which, we have heard, can be very pleasurable in itself—although we'll never know personally.

Bentham's method for gathering idiosyncratic pleasure data is what he called his "felicific calculus," a happiness algorithm, and it seems to anticipate the self-evaluation tests that we currently see in pop magazines and on the web. We can take a

multiple-choice Life Values Assessment Test to discover what we really and truly want in our lives. Or maybe a Sex Personality Test to find out if we are "sexual daredevils" or "sexually uncreative." Fascinating—well, up to a point.

Bentham's self-evaluation test was every bit as complex as cartoonist Mark Godfrey's "How cool am I?" calculus and just as flaky. But Bentham did have a laudable goal in mind with his felicific calculus. He said that in every situation the ethical thing to do is whatever creates the greatest happiness for the greatest number of people. But since each individual has his own particular gratifications and pains, and each of them has different strengths, we must perform a calculation to figure out what will create the greatest aggregate happiness. Here's how Bentham said to figure out how to make ethical utilitarian decisions while taking individual happiness quotients into account.

First, determine the degree of each pleasure or pain caused for each person affected by your decision, according to these factors:

- How long the pleasure or pain will last
- How certain it will be to occur
- How soon
- The probability that it will be followed by other similar sensations (pleasure followed by pleasure or pain followed by pain)
- The probability that it will be followed by other dissimilar sensations (pleasure followed by pain or pain followed by pleasure)
- How many people will be affected

Then, using the above values, calculate the sum of all the pleasures and pains caused by the action for each person affected by it:

- Add up all the pleasure values.
- Add up all the pain values.
- Do the maths.

Voilà! You now know what to do!

Any questions?

It turns out utilitarianism has other problems besides the complexity of its algorithm for happiness. Two philosophers, one British, one American, created a thought experiment—the trolley problem—that has become popular on university campuses. It is a challenge to the principles of utilitarianism. Originally posed by philosopher Philippa Foot and refined by Judith Jarvis Thomson, the puzzle involves two scenarios. The first asks what you would do if you saw an out-of-control trolley heading for five people on the track, and you also saw that you could divert the trolley by throwing a switch that would send it onto a siding, where, alas, there is also a person—but only one. Throw the switch, right?

For most people, this is a clear case of the greatest good for the greatest number. And the algorithm is really simple: Count the number of lives lost; declare the action with the lower number the answer. (In a survey, most people go with Bentham on this one, although a minority say, "you shouldn't play God.")

Now imagine you're a surgeon who sees a way to save the lives of five people in need of various organ transplants by sacrificing one life. Remove all the organs of a perfectly healthy person and

redistribute them to the five. What's that you say? Bentham may not be the right guide here?

Maybe it's time for us to go back to the Sex Personality Test.

"I think your test grading is biased in favour of students who answer the test questions correctly."

Ethics Gone Wild

The little fellow in Aaron Bacall's cartoon should get an A+ for deadpan chutzpah. His argument is obviously ridiculous, right?

Maybe not, according to the contemporary Oxford moral philosopher and bioethicist Julian Savulescu. Along with fellow ethicist Peter Singer, Savulescu believes that performance-enhancing drugs should be allowed in Olympic sports because they level the playing field, as it were. Otherwise, he maintains, athletes with greater strength and natural ability have an unfair advantage. Just as students with more brain power and better natural study habits have an unfair advantage on tests.

While we try to wrap our minds around this counterintuitive argument, Savulescu goes on with the more reasonable point that it is impossible to draw the line between what is a legitimate performance-enhancing drug and what is not. Like, how about coffee? Or protein-rich Kobe steaks flown in fresh from Japan?

But back to that "levelling the playing field" argument. Savulescu met his match in a debate with the Australian

philosopher Robert Sparrow. Quipped Sparrow: "You could fire sprint racers out of cannons and they would go really fast. It would be performance-enhancing. But it wouldn't lead to anything that was entertaining, and it wouldn't reward the excellence that we think of as being valuable in sport."

Point, Sparrow! And bad news for the boy in Bacall's cartoon.

"It's getting much harder for me to distinguish
good from evil. All I'm certain about is what's
appropriate and what's inappropriate."

Doing What Comes Naturally

The devil in master cartoonist Ed Koren's scenario is doing a masterful job of dodging the old good-and-evil question.

Philosophers since the Greeks have tried to pin down what it means for something or someone to be good. Aristotle thought the good life is the flourishing life; the Stoics, that it's the life lived in accordance with the rational structure of the universe; the Epicureans, that it's the life of quiet pleasure. Bentham defined the good as the greatest happiness for the greatest number; Nietzsche said it's the life of self-actualization; and the twentieth-century existentialists said that it's the life of being true to oneself.

But it's not always clear whether these philosophers thought they were *defining* what "good" means or only saying what *paths* lead to the good. Yet there were some nineteenth-century philosophers, like social Darwinist Herbert Spencer, who clearly thought they had found the very definition of good. Spencer thought that evolution is generally moving toward universal human pleasure and happiness and that, *therefore*, the good *equals* the pleasurable.

Twentieth-century British philosopher G. E. Moore claimed that Spencer had committed what Moore called the "naturalistic fallacy." Think about it, said Moore. Is asking, "Is the pleasurable always good?" the same as asking, "Is the pleasurable always pleasurable?" Of course not, he retorted to himself. Of course the pleasurable is always *pleasurable*. I want to know if it's *good*! And with that he quoted one of the wildest—and possibly wisest—statements in all philosophy: Bishop Joseph Butler's "Everything is what it is and not another thing." Good is *good*. Period. It cannot be reduced to something else.

Note that the devil in Koren's cartoon is careful not to commit the naturalistic fallacy. His scepticism about the meaning of "good" and "evil" doesn't lead him to *equate* them with "appropriate" and "inappropriate." He merely thinks good/evil is a tougher call. We do too.

What If Your Right Is My Wrong?

Moral Relativity

"You say sex pervert. I say horse enthusiast."

Whoa!

The fellow in naughty Matthew Diffee's naughty cartoon is explaining (to his wife?—*yikes!*) a basic tenet of moral relativism: that all ethical judgments are right or wrong only relative to a particular point of view. And further, no one point of view is inherently better than any other.

Most moral relativists believe that codes of conduct are culturally based and that they are neither universal nor objective, as, say, science supposedly is. Because moral relativism is not a set of ethical principles or axioms in itself, philosophers usually categorize it as a type of metaethics—the study of what the philosophy of ethics is and what it can and cannot provide.

So, according to moral relativists, if, in one culture, having an intimate relationship with a horse is okeydokey, then people in another culture who find it reprehensible from their POV (even if it is consensual) should be absolutely tolerant of it. Or at least keep their moral judgments to themselves. Different strokes for different cultural folks, so to speak.

(Of course, the man in the cartoon is probably from the same culture as his interlocutor, so what he is proposing is a kind of

micro moral relativity, one that varies not only from culture to culture but from individual to individual.)

The sixteenth-century French philosopher Michel Eyquem de Montaigne—Lord Montaigne—was the first modern philosopher to propose moral relativism as the way to go. In his essay "Of Cannibals," he states that eating the dead bodies of enemies is no worse than many barbaric practices in "civilized" Europe, in particular, the torture of prisoners.

Some say that Montaigne was only *describing* the way morality works in different societies, not how it *should* work. But to others, it seems pretty clear Montaigne was arguing that the belief that one's own society's moral code is superior to another's is just plain hubris.

The contemporary American moral philosopher Martha Nussbaum thinks moral relativism is not only wrong, it's bad. Drawing on Aristotle, she maintains that there is only *one* true set of moral principles and these are based on the universal human situation in all cultures, stuff like common human fears, appetites, and the common need for land and shelter. From these, she says, follow the Aristotelian virtues of courage, justice, and magnanimity. Apparently, some cultures just don't get Aristotelian philosophy.

Interestingly, this cartoon by the veteran *New Yorker* cartoonist Matthew Diffee was rejected by that magazine for being off-colour.

A moral relativist might respond: "You say it's in bad taste. We say it's a creepy smiler."

"John's in charge of advising us on ethical matters, but to be honest, I've never had much confidence in him."

Hot Damn, That's Good!

What Bradford Veley is presenting in this cartoon is a scathing critique of A. J. Ayer's logical positivism as it relates to ethics. But we're sure you made that connection already.

For millennia, philosophers have been trying to figure out what is good and what is bad, and what makes stuff good or bad. Being philosophers, they aimed for the highest level of abstraction: what *fundamental* principle can be found that would serve as the starting point for all individual moral decisions down here on the ground? And on top of that, they wanted this basic principle to be rational—true and provable.

Along the way, we got all kinds of ethical systems and basic moral principles, some of them hard to grasp, some of them useful, and all of them earnest. But did any of them pass the true-and-provable test?

Not a one, according to the eminent twentieth-century logical positivist Sir Alfred Jules Ayer. In his highly readable and influential book *Language, Truth, and Logic*, "Freddie" (as he was known around Oxford) asserted that moral principles and pronouncements are nothing more than personal

expressions of emotion. So declaring "Stealing toys from babies is bad" is simply a show of feelings, no different from shouting "Whoopee!" when winning the lottery or "Oh, phooey!" when being thrown out of a pub. This type of nonrational "ethics" became known as "emotivism." It wasn't what we usually think of as ethics at all.

Ayer's principal point was that moral statements could not be proven by either analytic logic or the rules of inductive logic used in empirical science. One can give her reasons for not stealing toys from babies, but the moral assumptions informing those reasons just aren't provable. Sorry. ("Sorry" is just another expression of personal emotion, sorry.)

To most people, Ayer's analysis seems totally counterintuitive. Deep inside, we just *know* that there must be objective right and wrong. Indeed, many of us claim to know this on good authority, none other than God himself, who dictated the Ten Commandments to his tablet maker, Moses. But Freddie wasn't buying this one either, for the simple reason that there was no way to prove the existence of Moses's alleged decree writer.

John, the corporate ethics consultant in Veley's cartoon, appears to have taken logical positivism to heart. If we assume that the management team is looking for rational, rather than emotional, ethical advice and that John *always* flips a coin to make decisions, then we can assume he is a logical positivist, because he sees no way to argue rationally that one course is better than any other.

For this, you need an ethics consultant?

"The problem is I can't tell the difference between
a deeply wise, intuitive nudge from the Universe and
one of my own bone-headed ideas!"

I Can Feel It in My Bones

It's our ethics-maven-cum-cartoonist Bradford Veley again, this time with his critique of ethical intuitionism.

The nineteenth-century British philosopher Henry Sidgwick was among the first to espouse this moral theory, with its claim that basic moral principles are simply self-evident. They are just there, plain as the proverbial nose on your proverbial face. They are not derived from other principles. You simply intuit them, the same way you intuit, say, that the man behind the fish counter thinks you're hot, even though he's never so much as said hi. What is more, Sidgwick maintained, these intuited moral principles are universally binding on all people. Ethical intuitionists, in other words, stand at the opposite end of the spectrum from the moral relativists.

Here Veley asks the obvious question: How can we know that the principle we seem to be intuiting "from the Universe" isn't just another one of our wacky ideas? This seems particularly pertinent to the gentlemen in the drawing, who appear to have been sitting outdoors for a very long time, perhaps indulging in a toke or two. But the question resonates for all of us.

Sidgwick had some answers to this. He said we can have a high level of confidence that a moral principle is truly self-evident if: (a) it is clear and distinct; (b) we arrived at it by careful reflection; (c) it's consistent with other seemingly self-evident truths; and (d) most people buy it.

Okay, but then how come there's such widespread disagreement about moral principles? If they are self-evident and available to everybody who is intuitive, why are there so many moral disagreements among people?

Here the ethical intuitionist has several arrows in her quiver. Perhaps an apparent disagreement about moral actions may really be a disagreement about the facts of the case. As contemporary British philosopher Philip Stratton-Lake points out, we might disagree about whether it is a fact that lobsters feel pain in boiling water, while still agreeing with the moral principle that it is wrong to deliberately inflict pain.

Also, as Stratton-Lake points out, an apparent disagreement about a moral principle may turn out instead to be a disagreement about how much weight to give the principle as it rubs up against other moral principles. Two people can agree on the same principles—say, (1) nobody should be allowed to steal, and (2) nobody should be allowed to starve to death. Yet one can easily imagine a particular situation where these two principles would come in conflict—one where a starving man steals food. And we can also easily imagine two people with the same basic principles disagreeing on which prevails in this situation.

Still, it's hard to claim we can ever be *totally* certain that our moral intuitions aren't just the ideas of our inner bonehead. Even

Sidgwick considered intuitionism only one leg of a three-legged stool, along with egoism (ethics based on the happiness our actions cause in us) and utilitarianism (ethics based on the happiness of all affected by our actions). He attempted to reconcile these three legs in his magnum opus, *The Methods of Ethics*, but many critics still found the stool wobbly.

XVI

Is Love All There Is?

Eros and Beyond

"Yes, Doreen, I think I am *capable* of unconditional love."

Love Is Never Having to Say,
"I'm Outta Here!"

Here's provocative cartoonist Leo Cullum again, this time weighing in on that amorphous phenomenon that is said to make the world go 'round: love.

Love is a problem—starting with the many meanings of the word itself, which are all over the place.

"I *love* Ben & Jerry's Chunky Monkey ice cream."

"Cheri *loves* her children more than life itself."

"Bob is really *in love* this time—with Lucy-Mae, of all people."

"Father Daly *loves* God totally."

Western philosophers have been trying to pin down the various meanings of "love" since the first Greek's heart went pitter-pat. Early on, the Greek language organized the diverse kinds of love that humans experience into eight different and distinct words: *eros*, after the goddess of the same name (which encompassed not only erotic love, in our sense, but any love in which the lover wants something the beloved has, as in the love

of the apprentice for the master artisan); *philia*, or affectionate love (*philosophia* means "love of wisdom"); *storge*, or familial love, as in love for children and parents; *ludus*, or playful love (think: pitter-pat); *mania*, or obsessive love (thought to be an imbalance of *eros* and *ludus*); *pragma*, or enduring love (as in a couple married for forty-plus years); *philautia*, or self-love; and the highest form of love, *agape*, or selfless love.

One of the first Greeks to opine on love was Diotima of Mantinea, a high priestess who plays a role in Plato's famous dialogue on love, the *Symposium*. Socrates says that in his youth Diotima taught him the genealogy and philosophy of love, and that all love aims at pondering the divine. Sure, there's all this lovey stuff down here between humans, said Diotima, but those are just hints and jolts to make us appreciate the wonder of the gods.

Love became a hot topic in philosophy through the ages, with everyone from Empedocles to Rousseau, from Saint Augustine to Kahlil Gibran, chiming in. But when it comes to the concept of love brought up in Leo Cullum's hilarious cartoon—"unconditional love"—we need to go directly to one of the greatest Christian thinkers of all time, Søren Kierkegaard, and his opus, *Works of Love*.

In that work, he explores the implications of the divine commandment to love your neighbour as yourself. First he points out that by "neighbour," Jesus meant everyone everywhere, including the contrarian Samaritans (yikes!), not just the people next door. But most important, he distinguished between "preferential love" and "unconditional love," the former being the kind that we usually experience. Preferential love can be expansive, but it always

has its limits, as in, "I loved Bob passionately right up until he emptied my bank account." For Kierkegaard, preferential love just doesn't do the trick. It is not *real* love.

Kierkegaard is a no-hugs-barred absolutist in his concept of unconditional love. He wrote, "Who is stronger? He who says, 'If you do not love me, I will hate you,' or he who says, 'If you hate me, I will still continue to love you'?"

We think we know the answer to that one.

And so does our dog, God love him.

"Hold that thought. I have to go take a number five."

I Feel You!

Closely related to love is the feeling of empathy. And this ditzy (or, as some might say, "juvenile") cartoon from Eric Lewis raises the question of just how far our feelings of empathy can take us.

The principal philosopher of empathy is Edmund Husserl, a German philosopher of the late nineteenth and early twentieth centuries.

Husserl said that we humans have several unconscious beliefs about the world and particularly about other people. One is that any being who looks and acts more or less like me will have a singular personal viewpoint, just as I do. This means that he or she will experience the world from some particular point of view, just as I do. Her viewpoint may be very different from mine, but I unconsciously assume that she has one. We do not make the same assumption about, say, a rock. Or a robot. This may seem obvious, but Husserl's point is that the very reason it seems obvious that other people have a point of view is that this belief is so basic we do not even count it as a belief. It is an automatic assumption that we are rarely conscious of. *But it is fundamental to our understanding of the world.*

Another one, Husserl says, is that I have an unconscious belief that I can more or less access another person's point of view by "putting myself in her shoes," and that, if I look at things from her point of view, I will see the world more or less as she does.

Common sense? Yep. Again, that's pretty much Husserl's point. These beliefs are so fundamental to the way we actually live in the world that any philosopher who questioned them—*and some have*—would just be flapping his gums. Can we "really, really" access another's point of view? Can we be "objectively certain" that she even has a point of view? What if science "proved" we can't? Husserl says we wouldn't credit any science that "proved" such a thing, because we *must live our lives* as if those beliefs are true. Husserl called this web of beliefs the "life-world" (*Lebenswelt*) and the process of accessing another's point of view, "feeling into," or empathy (*Einfühlung*).

There are, nonetheless, levels in our ability to "feel into" another's point of view. With those people with whom we share a culture and a language (our "home-world"), we may have very specific empathetic responses to their behaviour. But with those from radically different cultures, we are not so confident of our ability to feel into the meaning of their specific behaviour. Still, we assume we can feel into their "universal" point of view, like what it means to them to have a body or to occupy space or to believe in causality.

Cartoonist Eric Lewis is raising here what may someday turn out to be a very important question: To what extent can we feel into the meaning of the behaviour of a strange visitor from another planet—particularly his experience of having to take a

wicked number five? Mr. Lewis cunningly plants some clues that this is a being who in some respects meets Husserl's criteria of "acting like me." He can fly a spaceship. He speaks English. His partner has "thoughts" and can apparently "hold" them. And, most important, he seems to experience some urgency in his need to "take a number five." He even uses a numerical typology—albeit somewhat larger than ours—to identify his needs. Moreover, by having to go somewhere else to take this "number five," we can perhaps assume that it is an act not generally done in the presence of others.

The philosophical point Mr. Lewis is clearly making is that, even though we can't empathetically discern the precise meaning of his need to "take a number five," we can still put ourselves to some extent in his shoes—or possibly his boxers.

"'Empathy'?—that doesn't sound very adaptive!"

Survival of the Most Tenderhearted?

The prescient cavepersons in Baloo's cartoon raise an interesting question about the survival of their species.

At first look, the human capacity for empathy does *not* seem to qualify as a survival characteristic, as in the "survival of the fittest" theory. Like what if I'm so busy feeling somebody else's pain that I fail to notice that stone axe he's carrying behind his back? Doesn't sound real adaptive, to be sure.

Yet findings in the relatively new field of evolutionary psychology suggest that empathy actually does promote survival. Not only is this trait fundamental for nurturing our offspring so they can grow and reproduce, but it pays off in cooperation, as in, "You lift that end of the boulder and I'll lift the other. Whew, together we just created the first cave door." In other words, empathy can be a form of enlightened self-interest. It's a win-win.

But according to Harvard moral philosopher and experimental psychologist Joshua Greene, empathy has its limits. At some point, it can be hazardous to your health. Greene postulates that empathy and cooperation work beautifully within the group—family, tribe,

bridge club, Hell's Angels. There it gets the job done efficiently. But empathy works pretty badly in us-vs.-them situations, as with that tribe on the other side of the mountain that crosses over, smacks us in the head, and abducts our children on moonless nights. For survival, a combination of empathy and wariness is optimal.

Interestingly, evolutionary psychologists have also concluded that societies that embrace religions are more likely to survive than those that do not. God knows why.

"I don't sing because I am happy.
I am happy because I sing."

Love Is But a Song We Sing

Rare is the cartoon whose caption is a quote attributed to a noted philosopher. But here *New Yorker* cartoonist Edward Frascino uses a line allegedly uttered by the great American philosopher William James.

Frascino can be forgiven his apparent plagiarism, because the line has a life of its own, especially among feel-good pop psychologists and New Age gurus, who take James's words to mean something like, "Don't worry, be happy" or "Accentuate the positive."

But that is not what James meant at all.

First, it should be noted that in James's time, psychology was just beginning to separate itself from the discipline of philosophy, and his book *The Principles of Psychology* was a very philosophical work indeed.

In his essay "What Is an Emotion?" he examined the cause-and-effect relationship between bodily instincts and emotions. In James's famous example, that sequence is *not* "I see the bear, I fear it, so I run." Rather, it is "I see the bear, I instinctively run from it, and that physiological reaction causes me to feel fear." Our

consciousness of our churning legs, accelerated heartbeat, and surge of adrenaline *is* the emotion.

Ditto for crying and feeling sad.

And ditto encore for Frascino's birdie, who sings *instinctively* and therefore feels happy.

It turns out love really is but a song we sing.

XVII

Why Won't God Tell Us Whether He or She Exists?

Theism, Proofs, and Strategies

Thinking Bigly

Who says ants can't think big? Not Syrian cartoonist Fadi Abou Hassan. His little ant is having one huge idea—elephantine, in fact. But, impressive as it is, the biggest idea an ant can have is still finite. His ant-size brain cannot conceive of the very idea of the infinite. So, implies Hassan, he will never be able to understand Saint Anselm's ontological argument for God's existence. (Actually, we don't follow it completely either; but more about that later.)

Yet, before we even get into so-called proofs of God's existence, we probably should ask, Who needs a proof anyway? God (or gods) just *is* (or *are*), right?

Indeed, for millennia people didn't even entertain the idea that gods might not exist. In the Western world, sceptics and doubters did not appear on the scene until the fifth century BCE, when the Greek teacher Diagoras floated the idea of atheism. And wouldn't you know it—he was a philosopher, i.e., a troublemaker.

Other pre-Socratic atheists followed, including Prodicus, who rather patronizingly offered a psychological explanation for those who stubbornly persisted in believing the gods were real. He said

that primitive man, out of simple admiration, deified the fruits of the earth and virtually everything that contributed to his existence.

A few millennia later, the Austrian psychologist and sometime philosopher Sigmund Freud added to Prodicus's psychological analysis in his seminal essay "The Future of an Illusion," in which he calls belief in God a "wish fulfilment," the gratification of a fervent wish via an imagined reality. Religion, wrote Freud, is a psychological fulfilment of the "oldest, strongest, and most urgent wishes of mankind." That would be the wishes for eternal life.

Strictly speaking, demonstrating that a belief has a psychological origin does not prove that this belief is necessarily wrong. After all, God could be revealing himself by using a psychological mechanism. He could be saying to himself, "The only way I can get Moses to believe in me is by deluding him into believing that I'm lurking inside a burning bush. Hey, if it works, it works." Or, the fact that belief in the existence of God has psychological benefits may just be a nice side benefit, like belief in the existence of love. Feels good.

In any event, with the arrival of atheists, other philosophers took on the task of proving them wrong and demonstrating that God or gods really do exist. And so back to the ontological argument.

It was put forth in its best-known form by Saint Anselm of Canterbury in the eleventh century. A pared-down version goes like this:

First, part of what we mean by God is that he is the greatest being that can be conceived. Anything that wasn't the greatest being that can be

conceived wouldn't be God. It's like saying there is no conceivable number greater than infinity. If you say, "Oh, yeah? What about a gazillion gazillion?" hopefully someone would take you aside and gently say, "If you think infinity is smaller than a gazillion gazillion, you don't know what 'infinity' means."

At the very least, such a being can exist in our minds, if not in the real world. We are able to conceive of the idea of a Greatest Conceivable Being (and it is way bigger than even an elephant). We may not be able to put a face on this concept, let alone a long white beard or high heels, but we can hold in our heads the idea of the Greatest Conceivable Being.

So either he exists only in our minds or he exists both in our minds and in the real world. So far, we're with you, Saint Anselm.

But then comes Saint Anselm's tricky jump, so fasten your parachutes: Says Saint A., if he existed only in our minds, a greater being actually *could* be conceived—one that exists both in our minds *and* in the real world. Therefore, he must exist both in our minds and in the real world.

Huh? Something smells fishy there, and a contemporary of Anselm, the monk Gaunilo, retorted that Saint Anselm's ontological argument could also prove the existence of a perfect island that no one has ever seen, so it doesn't actually prove anything, does it? We see the ontological argument deflating like an elephant balloon in Macy's Thanksgiving Day Parade.

But wait!

A Pile of Analogs

There is something refreshing about cartoonist Baloo's egotistical and defensive God. It makes us feel we really were created in his image. But what exactly is it that such a God finds offensive about the concept of intelligent design?

The second classical "proof" of the existence of God is called the "argument from design," and its best-known version is the "argument from analogy." It goes like this:

In our everyday experience of ordinary objects, when we come across something that shows a lot of evidence of design—say, Pokémon Go—we conclude that a person must have designed it. And it turns out we are absolutely right about that; his name is Satoshi Tajiri. (He had loads of helpers, though.)

So, by analogy, the universe itself, which clearly shows evidence of design and is way more complex than Pokémon Go, must have had a designer way smarter than a person, even smarter than Satoshi.

Well, that designer is called God! End of argument by analogy.

Saint Thomas Aquinas approved of a version of the argument

from analogy. But several centuries later, the British empiricist David Hume replied that there can't possibly be anything analogous to the universe. The universe is the Whole Deal—it's *everything*—so, by definition, it's unique. You simply can't create an analogy to Everything. So much for the second "rational" proof for the existence of God.

We think the reason Baloo's God finds the argument so offensive is that he can picture this God saying, "What? I'm supposed to be flattered that I'm a way smarter designer than Satoshi Tajiri? Please. I created him, for God's sake!"

It's Turtles All the Way Down

Here, the British cartoonist known simply as Banx traces the seemingly infinite number of 3-D printers to a First Printer. But he is ignoring a key question: Why does there have to be a first cause of anything? Why can't causes go back to other causes infinitely? Maybe there is no original 3-D printer, but rather 3-D printers going back in time ad infinitum. Thus does Banx raise a critical question about the third argument for the existence of God, known as the "cosmological argument" or "first-cause argument." Thanx, Banx.

Both Plato and Aristotle put forth versions of the first-cause argument, as did Saint Thomas and several Muslim philosophers in the Middle Ages. It's a fairly simple argument, so we'll run it by you in its most elementary form:

1. Everything that exists has a cause.
2. The universe exists.
3. Therefore, the universe has a cause—let's call him God.

The counterargument, that there may not be a first cause, is a

hard one to get our minds around for sure. But the cosmological argument doesn't seem to help. If we're willing to say that God doesn't need a cause, why not just say the universe doesn't need one? And 3-D printers don't need one either. So there.

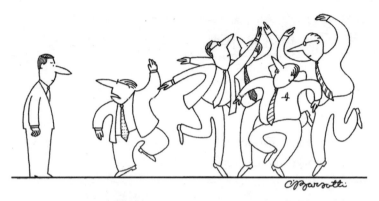

"Maybe you're right, maybe it won't ward off
evil spirits, but maybe it will, and these days
who wants to take a chance?"

Place Your Bets, Please

Here, the adroit cartoonist Charles Barsotti nails Blaise Pascal's famous "wager" on the existence of God. Forget about proofs, says both the dancer in the cartoon and Pascal *lui-même*; just focus on weighing outcomes.

Proving God's existence turned out to be a tougher assignment than philosophers bargained for. So the seventeenth-century French philosopher Blaise Pascal, a brilliant mathematician and scientist, took a totally different approach to the problem. The wager is not a *proof* of God's existence—Pascal believed no rational proof was possible. Rather, he offered a *strategy* for living that was based on weighing the value of possible outcomes. He said that living one's life as if God exists is the best route to take because such a life has everything to gain—like eternal life in God's heaven—and little to lose. On the other hand, if one lives one's life as if God does *not* exist, one has a whole lot to lose—like eternal life in God's heaven. That's because nonbelievers aren't allowed through those Pearly Gates. After all, the gatekeeper, Saint Peter, does have his standards.

Do the maths, Pascal says. If you act as if God exists and it turns out that he doesn't, what have you lost? A few hours each week in church? A bundle of unanswered prayers? Big deal. But if you act as if God exists and it turns out that he really does, you win big-time. Conversely, if you act as if God doesn't exist, and it turns out he does, you're in deep weeds. Like, for eternity.

But wait, some people protest. If you act as if God exists, and it turns out he doesn't, haven't you also lost out on something major: the opportunity to do some really cool sinning?

Pascal had a response to the would-be sinner's caveat. As a mathematician of the first order, he had developed probability theories on various gambling problems in correspondence with another mathematician, Pierre de Fermat. Professor Pascal was very good at complex calculations of probability. So we picture him reasoning something like this:

"Hmm, if I act as if God exists, and it turns out he doesn't, I'm definitely going to miss out on some riotous sinning. Sure, it's only for this finite life, but if this finite life is all there is, then, in a way it's sort of, like, eternal. On the other hand, a lot of sinful stuff may not be that much fun in the long run anyway. Let's see: murder—usually a bad deal for the murderer in the end; adultery—tougher call, but on balance probably not an unadulterated blast, especially when you factor in the likelihood of getting caught; coveting my neighbour's manservant or his maidservant or anything that is my neighbour's—not that much of a downside, but really, how great a housekeeper can my neighbour's maidservant be? Does she do windows? So, bringing it all together, and comparing the relatively minor loss of the

enjoyment of sin with the loss of eternal life, I still think the odds favour behaving as if God does exist."

Published posthumously in his treatise *Pensées*, Pascal's wager introduced a whole new way of looking at the faith-in-God quandary. He was the first to make it a *pragmatic* problem, like calculating the pros and cons of whether you should go to the movies or stay at home and watch TV. More important, he was the first to make it a *voluntary* issue; one gets to *decide* whether or not she believes in God. This means, for example, that one doesn't have to wait around for God to reveal himself. Just do it: *Believe!*

I'm Leaving It All Up to You

What is Santa up to here in Aaron Bacall's droll cartoon? Can he really be looking for proof of his own existence? That would entail having to swallow some pretty irrational stuff. To believe that he exists—i.e., that he is really Santa—he would have to believe, among other things, that he lives at the North Pole with Mrs. Claus and assorted elves and that his primary purpose is to distribute gifts to good little boys and girls all over the world on Christmas Eve, while passing over the ones who have been naughty. He would have to accept the idea that he can get his essential tasks done in real time all over the world in one night, with only the help of a few elves and a sleigh motored by flying reindeer. No wonder he looks puzzled. That kind of proof isn't going to happen.

What Santa doesn't realize is that the book, which he probably found on the Self-Help shelf at his local Barnes & Noble, isn't about whether you exist. It's about having trust or faith or confidence in yourself as a person. And you're not going to get to that kind of confidence by some kind of proof. You're going to need to make a passionate commitment, a leap of faith.

This is the revolutionary change that the nineteenth-century Danish religious thinker Søren Kierkegaard brought to the way we think about belief in God. Both philosophy and theology, he said, make the mistake of treating knowledge of God as an objective question. The basic issue for philosophers down through the ages has been "Does he exist?" And the usual way of trying to answer it was by rational proofs, either pro or con. But faith in God, said Kierkegaard, isn't like that. Faith is subjective. It's a matter of passion rather than of logical thought.

He said that we do not *understand* religious truth; we espouse it, we accept it, we embrace it. We do not add it to our store of stuff we know. It's the other way around: *It* transforms *us*. And when our passionate embrace of this transformation is so strong that it overcomes our doubts about the questionable objective "truths" of religious statements, then we have faith. There is something existentially logical about this transcendence of logic.

So the real question isn't "Does God exist?" It's "Are you passionate enough in your appropriation of the Eternal to put objective reason aside and take a leap of faith?" Can you dig down deep inside yourself and face the mystery of life and death and the seeming meaningless of it all—to wrestle with that inscrutable enigma—and *then* leap to an objectively irrational faith?

It's all on you, brothers and sisters. That means you too, Santa.

Philosophy, Schmolosophy, Who Needs It?

Metaphilosophy

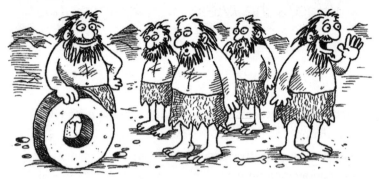

"Quick, everyone! Thog's invented the cartoon situation!"

What's the Meta with Philosophy?

What British cartoonist Clive Goddard has produced here is a metacartoon—a cartoon about cartooning. He's taken a classic cartoon setup, primitive man inventing the wheel, and, in the cartoon, commented on it as a classic setup for a cartoon. (By the way, other classic cartoon setups include a man stranded on a tiny island, a psychiatrist and his patient on a couch, and the ever-popular Saint Peter at the Pearly Gates.)

Meta comes from the ancient Greek, meaning "after" or "above," and is usually used as a prefix to mean "about itself or its own category." For example, "meta-analysis" is defined as "an analysis performed at a higher level of abstraction than that of basic analysis," and "metafiction" is defined as "self-referential literature concerned with the art and devices of fiction itself."

Not to feel left out, philosophy has its own "meta": metaphilosophy, the philosophy of philosophy. The head spins. This vertigo may be recognizable to those readers who have experimented with psychedelics as the point at which you find yourself looking at yourself having a hallucination of looking at yourself.

Metaphilosophy is basically the study of what philosophy is all about, sometimes drifting into the area of what philosophy *should* be all about, and why we should care. But, of course, philosophers and metaphilosophers like to argue about whether or not it is a legitimate area of study—call it meta-metaphilosophy.

The final word on metaphilosophy comes from the metaphysician Martin Heidegger, who wrote in his essay "What Is Philosophy?": "When we ask, 'What is philosophy?' then we are speaking *about* philosophy. By asking in this way we are obviously taking a stand above and, therefore, outside of philosophy. [So far, so good.] But the aim of our question is to enter into philosophy, to tarry in it, to conduct ourselves in its manner, that is, to 'philosophize.' The path of our discussion must, therefore, not only have a clear direction, but this direction must at the same time give us the guarantee that we are moving within philosophy and not outside of it and around it."

Got that? It may become clearer with your second helping of magic mushrooms.

Maybe I Should Have Majored in Computer Science

As Danny Shanahan's poignant cartoon illustrates, there's a more practical dimension to the question "Why philosophy?"

This cartoon went viral among philosophy students and graduates the day it appeared, joining the comedic riddle:

What is the first question asked by a philosophy graduate?

Answer: "Can I Super-Size that for you, ma'am?"

No doubt about it: A profound understanding of Kant's categorical imperative or of Russell and Whitehead's *Principia Mathematica* doesn't exactly prepare one for big-buck jobs. Or any job, for that matter, except teaching the categorical imperative and *Principia Mathematica* to other bubbleheaded philosophy majors.

So why, you may ask, do we do it?

Throughout the ages, philosophers have weighed in on the value of studying this often impractical stuff. And our favourite

responses come from a wise old Greek, Socrates, and a recent magnanimous Brit, Bertrand Russell.

At his trial for corrupting the youth of Athens with his relentless philosophical questions, Socrates offered this stunning reason for studying philosophy: "The unexamined life is not worth living."

His judges, of course, were unmoved and sentenced him to death, a fate that may very well await the poor shlub in Shanahan's cartoon.

More uplifting is Russell's pithy thought in his essay "The Value of Philosophy": "Through the greatness of the universe which philosophy contemplates, the mind also is rendered great."

You said it, Bertie. And not only that, but philosophy also expands our appreciation of cartoons.

Biosketches

Anselm of Canterbury

Saint Anselm (1033–1109) is known principally today for his ontological argument, which most subsequent thinkers found unconvincing. On the other hand, his own existence was indubitable; and it was rich and eventful. He was born in Italy and at the age of fifteen had an intense longing to enter the monastery. His father was opposed, so Anselm lived a secular life for the next twelve years before finally becoming a monk. His leadership qualities were immediately obvious, and within three years he had been elected abbot and instituted a school that quickly became a hub of theological learning.

In the year 1093, he was appointed archbishop of Canterbury against his will. He fought on and off, first with King William Rufus and later with King Henry I, over reforms he proposed for the clergy and monks, and he spent periods of exile and self-exile from England.

One of the societal reforms he succeeded in implementing toward the end of his life was the prohibition of the sale of human beings. Good call.

Thomas Aquinas

Saint Thomas Aquinas (c. 1224–1274) was born near Naples to Landulf, count of Aquino, and his wife, Theodora. His parents always foresaw a religious vocation for young Thomas, but, unfortunately, not the one he chose: the new evangelical order, the

Dominicans, or Order of Preachers. Ah, the wildness of youth! His parents were so incensed at this outrageous adolescent rebellion that they sent his brothers to bring him back to the family castle, where they placed him under house arrest. They then allegedly sent a prostitute up to his room, hoping he would come to his senses and return to the Benedictine abbey where he had lived as a child, become in due time the abbot of Monte Cassino, and add to the family's prestige. What family wouldn't?

But Thomas stuck to his guns, Theodora eventually relented, and Thomas went on to discover the works of Aristotle, Augustine, the Muslim philosopher Averroës, and the Jewish philosopher Maimonides, synthesize their work with his understanding of Christianity, and write huge theological tomes, like his *Summa Theologiae*. After his death, he was elevated to the elite status of Doctor of the Church, and his theology is still quite influential in the Roman Catholic Church.

Aristotle

Aristotle (384–322 BCE) was destined from birth to believe in universal telos. In Greek, his given name means "the best purpose"; you can't get much more teleological than that.

Like the other great philosophers of the Golden Age of Athens, he was a polymath: i.e., his studies included everything from polisci to maths.

Aristotle studied for more than twenty years at Plato's Academy, where his only recorded extracurricular activity involved gymnastics. Afterward, he became the personal tutor of kings, most famously Alexander the Great, and then returned to Athens to open his own academy, the Lyceum. It is not known if Plato's Academy and Aristotle's Lyceum engaged in an annual football game.

Augustine of Hippo
..

Saint Augustine (354–430) was born in North Africa, in what is now Algeria. He and his family were ethnically Berbers, but very cosmopolitan and very Romanized. They spoke Latin around the kitchen table. *Fieri velit iaculis.* "Please pass the sugar."

His adolescence was normally hormonal. He famously and poignantly prayed, "Grant me chastity and continence, but not yet." Later, he would write that the only way to avoid the evil of sexual intercourse is to abstain from marriage altogether. Interestingly, some people have been known to claim the exact opposite.

Augustine's theology and philosophy have been extraordinarily influential over the centuries. His view of time as subjective prefigures Kant's similar notion, and modern theologians like Paul Tillich have adopted his conception that God is beyond time in the "eternal now." His treatment of the psychology of alienation influenced Husserl and Heidegger.

Finally, Augustine's notion of original sin was affirmed by the Second Council of Orange in 529 and is part of official Catholic teaching today. The Protestant "Christian realist" theologian Reinhold Niebuhr got a chuckle out of *The Times* quip, "The doctrine of original sin is the only Christian doctrine that is empirically verifiable."

A. J. Ayer
..

Sir Alfred Jules Ayer (a.k.a. "A.J." and "Freddie") published his major opus, *Language, Truth, and Logic*, at the age of twenty-six, instantly making him the enfant terrible of the British philosophy scene. Ayer was born in 1910 and died in 1989. He married four

times, twice to the same woman, apparently having made a simple logical mistake the first time around.

Roland Barthes
· ·
Roland Barthes (1915–1980) was a French literary critic and philosopher whose work on language heavily influenced the avant-garde theoretical schools of structuralism and post-structuralism. (Can we get back to you later on what "structuralism" and "post-structuralism" mean? *Much* later.) He travelled throughout Europe, as well as in Egypt, Japan, and the United States, teaching and writing prolifically. In 1980, as he was walking home through the streets of Paris, he was hit by a laundry truck and died a month later. (See "Absurdism.")

Simone de Beauvoir
· ·
Simone Lucie Ernestine Marie Bertrand de Beauvoir (1908–1986) wrote prolifically, both fiction and nonfiction, and was what we would today call a public intellectual. She and Sartre had an open relationship that lasted several decades, and she would intermittently have affairs with various men and women. Despite her feminism, she certainly embodied one sexual stereotype: She cared less than most men about her paramour's looks. Sartre was not a handsome man.

In 1943, she was accused of having seduced her seventeen-year-old student and, as a result, eventually lost her license to teach. We suppose we should give her credit for her existential commitment: Both she and Sartre went on to campaign to overturn the age-of-consent laws in France.

Both her writings and her free lifestyle inspired an entire generation of feminists in the years after the publication of *The Second Sex*.

Samuel Beckett
· ·

Samuel Beckett (1906–1989) was an Irish poet, novelist, and playwright who lived most of his adult life in Paris, writing in both English and French. His work displayed a flair for finding something funny about the meaninglessness of it all, and he is considered one of the founders of the theatre of the absurd. When he won the Nobel Prize in Literature in 1969, the Swedish Academy declared that in his work, "the destitution of modern man acquires its elevation." Some readers have had a problem spotting that "elevation" part.

Jeremy Bentham
· ·

Jeremy Bentham (1748–1832) was a British philosopher and social reformer who thought that, as the population became better educated and more enlightened, it would see what was in its long-term interest and work toward promoting universal happiness. Okay, so that didn't work out, but he was still an interesting philosopher. He was a major influence on the work of John Stuart Mill and, more recently, Peter Singer.

George Berkeley
· ·

Irish Anglican bishop George Berkeley (1685–1753), a partner in the holy trinity of British empiricists along with John Locke and David Hume, held to the radical idea of "immaterialism." His "there's really nothing there" philosophy was roundly criticized, never so actively as by his contemporary Dr. Samuel Johnson, who kicked a large stone outside a church and declared, "I refute it thus!" (Johnson clearly didn't get it: Both the stone and his foot's collision with it could very well have been nothing more than "sense data.")

Berkeley was a bit of a wild man in his personal life also. At one point, he declared that distilled acid of tar (tar-water/turpentine) was a panacea. He wrote: "[It is a] cure for foulness of blood, ulceration of bowels, lungs, consumptive coughs, pleurisy peripheumony, erysipelas, asthma, indigestion, cachectic and hysteric cases [insanity], gravel, dropsy, and all inflammations."

Like Berkeley's philosophy, tar-water was an acquired taste.

Judith Butler

Professor Butler (1956–) is the gender-neutral Monarch of Gender Theory, a contemporary subdivision of political and moral philosophy. Her popular works "Performative Acts and Gender Constitution," *Gender Trouble: Feminism and the Subversion of Identity*, and *Undoing Gender* are considered the primary texts of the third wave of feminism and queer theory. In all of these, Butler argues that gender identity is not fixed, but fluid.

Albert Camus

Born in French Algeria, Albert Camus (1913–1960) became a world-famous French writer and intellectual, best known for his absurdist novels *The Stranger* and *The Plague* as well as his absurdist philosophical treatise "The Myth of Sisyphus."

Like Sartre, he was a Communist, although in 1937 he was denounced as a Trotskyite and expelled from the party. Camus then became associated with the French anarchist movement and during the war served in the French Resistance. He was the first prominent European intellectual to denounce the American use of the atomic bomb on Hiroshima.

In 1957, at age forty-four, he was awarded the Nobel Prize in Literature.

He reportedly once said that the most absurd way to die would be in an automobile accident. In 1960, returning to Paris from holiday in Provence, he was killed in a sports car driven by his publisher. Like many we've encountered, Camus's publisher was clearly an absurdist.

Jacques Derrida

Jacques Derrida (1930–2004) was an Algeria-born French philosopher, who became the darling of French intellectuals. To many English-speaking readers, however, his philosophy sounds like gobbledygook. Derrida's response: "Why is it the philosopher who is expected to be easier and not some scientist, who is even more inaccessible?" That sounds defensive to us, but maybe that's a misinterpretation.

René Descartes

The great French philosopher and mathematician René Descartes (1596–1650) is generally considered the father of modern philosophy, as well as the inventor of analytic geometry. Throw into the mix that he also had a law degree and wrote a book called *Compendium of Music*.

Like the late nineteenth-century philosophers Henry Sidgwick and William James, Descartes studied the esoteric knowledge of his day, developing a particular interest in the Rosicrucians, a mystical Catholic movement. In the end, though, he rejected their magical and mystical beliefs and opted for a scientific study of the world.

At the time, some thought he was a devout Catholic; others, that he was an atheist. After his death, the Catholic Church

placed his works in the Index of Forbidden Books. Several have attributed to him various religious last words, but it seems more likely that, as his valet reported, he died without saying a word. That sounds more like the demise we would expect from the great sceptic.

Diotima of Mantinea

Writing the biography of someone who may have gone by an entirely different name or names and who, indeed, may have existed only in someone's (Plato's) imagination raises certain epistemological questions. The biographer of the Tooth Fairy had similar problems.

But *if* she existed, and *if* her name was Diotima, and *if* she had those encounters with Socrates when he was a mere lad (in the fifth century BCE), and *if* she looked as fetching as she appears in Józef Simmler's nineteenth-century painting of her, then, well, wow! She is the Mother of Platonic Love.

Epicurus

Epicurus (341–270 BCE), fittingly, lived an Epicurean life. (No, Epicureanism has nothing to do with haute cuisine; that is a corruption of the term.) He lived on a hill on the outskirts of Athens in a place he called "the Garden," where everyone was invited to hang out, talk philosophy, and munch on bread and water, which, if appreciated properly, apparently tastes like haute cuisine.

Philippa Foot

British philosopher Philippa Foot (1920–2010) had an unusual American credential: She was the granddaughter of President

Grover Cleveland. Foot was one of a group of brilliant and famous women philosophers who were educated at Oxford during World War II. They included G. E. M. (Elizabeth) Anscombe, Mary Warnock, and Iris Murdoch.

Besides the trolley problem, she was best known for opposing the ethical subjectivism of A. J. Ayer (who thought moral statements are merely expressions of emotion, akin to saying "ouch" when you are struck by a blunt instrument) and R. M. Hare (who thought moral statements are nothing more than imperatives—"Do this, don't do that"). Instead, Foot revived the virtue ethics of Aristotle. She argued that moral constraints are a necessary part of *flourishing as a human being.*

She was a socialist and member of the Labour Party and voted to deny an honorary degree from Oxford to President Harry Truman because of the atomic bombing of Hiroshima and Nagasaki.

Michel Foucault

The French philosopher and social theorist Michel Foucault (1926–1984) is probably best known in the United States for his book *Madness and Civilization,* in which he traces the history of European society's understanding of madness and its "social construction" by the powerful in each period. In the Renaissance, he says, the mad engaged in ordinary society and were thought to have an odd wisdom. Today, the medical profession has succeeded in defining madness as an illness and sold the public on the idea that madness should be under the exclusive control of physicians and other "mental health" professionals. Until recently, the mad were frequently confined against their will—the ultimate power trip.

Interestingly, at about the same time, American psychiatrist Thomas Szasz was making a similar argument for the social

construction of mental illness in his bestselling book *The Myth of Mental Illness*.

As a gay man in the mid-twentieth century, Foucault had personal experience of being "socially constructed," and his work has become influential in feminist studies and queer theory. He died of complications from HIV/AIDS in 1984.

Viktor Frankl

The late Austrian philosopher and psychiatrist Viktor Emil Frankl (1905–1997) was the founder of logotherapy, which became known as the "third school" of Viennese psychotherapy. (The schools of Freud and Adler were numbers one and two.) A prisoner in the German death camps, Frankl had wrestled personally with the question of the meaning of life. Unlike Freud, who believed that humans' primary drive was sex, and Alfred Adler, who believed that it was "striving for perfection," Frankl believed that "finding meaning" was man's fundamental drive.

Joshua Greene

As both a philosopher *and* a psychologist, Greene (1974–) can be considered somewhat of an evolutionary throwback; only a century ago, psychology was considered a subsection of philosophy. Greene's best-known book, *Moral Tribes*, not only lays out his theories about the evolution of our moral sense, it suggests a programme for getting our intuitive moral thinking to cooperate with our deliberative moral thinking. In this way, he is also a throwback: He's an optimist.

Alan Hájek

Alan Hájek (1962–) is a professor of philosophy at the Australian National University in Canberra, where his many interests include the philosophical foundations of probability and decision theory. He has published award-winning papers with mind-bending titles like "What Conditional Probability Could Not Be" and "Probabilities of Counterfactuals and Counterfactual Probabilities." Many of us are hopeful that he will someday publish the definitive paper on the quantification of wood potentially chucked by woodchucks.

G. W. F. Hegel

Georg Wilhelm Friedrich Hegel (1770–1831) was born in Stuttgart in southwestern Germany. While at university, Hegel thought his future career would be as a *Popularphilosoph*, or popularizer of the philosophies of others. The rumour that he envisioned a book of philosophical cartoons is probably apocryphal.

In fact, he became a noted lecturer and writer of several very abstruse books, which, surprisingly, made him a bit of a rock star. In 1829, he was appointed rector of the University of Berlin. He died two years later, during the cholera epidemic, although, always the contrarian, he did not die of cholera. His last words were reportedly, "And he didn't understand me." No one understood what he meant by that.

Hegel had a major influence on later Western philosophy, although often through the work of thinkers like Marx and the existentialists, who radically opposed him. In other words, he was a victim of his own dialectic.

Martin Heidegger

Martin Heidegger (1889–1976) was a German philosopher who took on nothing less than what he called "the question of Being." Heidegger tried to describe what it is to Be rather than be Nothing, and, in particular, what it is to be an authentic individual. His major work, *Being and Time*, is probably as dense as any work of philosophy ever written. Somehow, though, like that other dense German writer Hegel, he became an academic celebrity, with hordes of students flocking to his lectures. He has influenced psychologists, theologians, and literary critics, in large part because of his description of the risk involved in individual human existence and the various ways we attempt to avoid that risk through conformity and self-distraction. He has also influenced generations of students, perhaps in part because his obscurity leaves plenty of room for improvisation in bull sessions.

Unfortunately, Heidegger was for a time in the 1930s a member of the Nazi Party and never made a formal disavowal of Nazism, even after World War II had ended. Instead, he retreated to his hut in the Black Forest, where he continued to write.

Heraclitus

Heraclitus was born around 540 BCE to wealthy parents in the Greek-speaking city of Ephesus in Asia Minor, then part of the Persian Empire and today part of Turkey. He died around 480 BCE.

Such a solitary and pessimistic fellow was this pre-Socratic wise man that he acquired the nickname "the Weeping Philosopher." And so full of questions-within-questions and paradoxes

were his philosophical writings that he also acquired the nickname "Heraclitus the Obscure." And so hard to fathom were many of his concepts that Timon of Phlius dubbed him "the Riddler." But Heraclitus's nicknames notwithstanding, he exerted a powerful influence on succeeding philosophers, including Plato and the Stoics. He is best remembered for his concepts of the perpetual flux of everything in the universe and the "hidden harmony" of it all, as in his famous dictum, "The death of fire is the birth of air, and the death of air is the birth of water." Some found this a bit obscure.

Thomas Hobbes

The British political philosopher Thomas Hobbes (1588–1679) was born prematurely when his mother went into a state of panic over the fact that the Spanish Armada was on its way. Hobbes later said his mother gave birth to twins: himself, and fear. If, as William James said, temperament determines personal philosophy, it is little wonder that Hobbes saw the natural state of human beings as frightening and the appropriate response, a strong monarchy. At the same time, he also championed many liberal ideas, such as individual rights, human equality, and the consent of the governed. Sounds like his mother had triplets.

Horace

The Roman poet Quintus Horatius Flaccus (65–8 BCE), better known in these parts as Horace, was considered then and now to be a charming but serious man and writer. His wit could be cutting, and the Roman satirist Persius observed that, even as his friend laughed, Horace would slyly pillory his every fault.

This double-edged skill served him well in the aftermath of the war that would decide whether, after Julius Caesar's death, Rome would continue to be an empire or revert to being a republic. Spoiler alert: Octavian (a.k.a. Augustus) and his forces prevailed and the empire lived on. Horace had been an officer in the defeated republican army, but was befriended by one of Octavian's ministers and actually became a spokesman for the empire.

As you might expect, there were two schools of thought on this switcheroo. Some thought he successfully walked the tightrope between being independent and co-opted. Others thought that he had become a well-mannered slave of Octavian's regime.

David Hume

Hume's mom realized early on that David (1711–1776) was "uncommonly wake-minded." That is to say that, like many of the great philosophers and cartoonists, David was extraordinarily precocious. When his brother went off to Edinburgh University, David, age eleven, joined him and read history, literature, philosophy, mathematics, and science. It doesn't get much more wake-minded than that.

In his adult years, Hume was known not only as a philosopher but also as a historian and essayist with a clear and elegant prose style. He is generally considered the most important English-speaking philosopher of all time, and he influenced the work of his friend Adam Smith as well as that of Charles Darwin and philosophers Immanuel Kant and Jeremy Bentham. His influence continues today; he is considered one of the forerunners of modern cognitive science.

Edmund Husserl

Edmund Husserl (1859–1938) was a phenom! In fact, he created the philosophical school known as phenomenology. Husserl was interested in describing what he called "lived experience," as opposed, say, to scientific descriptions of objects and how they act on one another. To Husserl, for example, the "night world" is very different from the "day world" in ways that have little to do with the rotation of the earth on its axis and everything to do with how we live in and experience day and night. So, the George Benson song "Give Me the Night" turns out to be about something other than the absence of sunlight. "'Cause there's music in the air, and lots of loving everywhere." Phenomenology.

William James

William James (1842–1910) is considered the preeminent American philosopher of all time and the father of American psychology. He had a wide-ranging mind, writing about not only epistemology ("What Pragmatism Means") and psychology (*The Principles of Psychology*) but also spirituality and mysticism (*The Varieties of Religious Experience*).

In pursuit of his interest in mysticism, he experimented with the mind-altering drugs nitrous oxide (laughing gas) and peyote. He said that it was only under the influence of laughing gas that he was able to understand Hegel. It is unknown whether or not he laughed when he did.

William James's brother Henry wrote a slew of famous novels. It is not true that the brothers held up stagecoaches on horseback.

Immanuel Kant

. .

Immanuel Kant (1724–1804) was a brilliant Prussian German philosopher known for his original work in epistemology (*Critique of Pure Reason*) and in ethics (*Critique of Practical Reason* and *Groundwork of the Metaphysics of Morals*). In epistemology, he found both rationalism (all reliable knowledge begins and ends inside your mind) and empiricism (most knowledge comes through your senses *to* inside your mind) sorely lacking, so he created a synthesis of the two. Immanuel also found social relationships sorely lacking, but that's another story.

Søren Kierkegaard

. .

Søren Kierkegaard (1813–1855) is generally considered the father of existentialism, although, ironically, he is generally believed to have been celibate his entire life and the father of no corporeal being. In fact, the best-known personal story about him is his breaking of his engagement to the young Regine Olsen, with whom he was passionately in love. He felt his constant melancholy would make him unfit to be a husband, and, to spare her the embarrassment of having been rejected, he pretended to be a scoundrel so that all the blame would fall on him.

He thought the popular philosophies of the day, particularly that of Hegel, tried unsuccessfully to systematize human existence, which he considered a mystery that could only be lived, not comprehended. He was consumed by the paramount mystery of his Christian faith, how the Eternal could appear in finite human experience. His scorn for the Lutheran Church of Denmark was even greater than his scorn for other philosophers. He

chastised the church for making a trifle of Christianity, making it into something that anyone could easily adopt. He felt that faith is properly understood as something that each person—as a lonely individual—must come to through his or her struggle with dread and despair.

Because he did not want his views to be received as just another attempt at an objective philosophy, he employed ruses such as writing ironically and writing under pseudonyms. He died at the age of forty-two, taking his alter egos with him.

Lao-tzu

Lao-tzu probably lived sometime between the sixth and fourth centuries BCE, although there is some question as to whether he ever existed at all. Legend has it that at the age of eighty, he set out in the direction of present-day Tibet, depressed that human-kind was unwilling to follow the path of *wu-wei* (nondoing). A border guard allegedly asked him to write down his teachings, and the brief manuscript became known as the *Tao Te Ching* (or, as some would have it, the *Dao De Jing*), meaning "The Book of the Way and Its Power."

Pierre-Simon Laplace

Pierre-Simon Laplace (1749–1827) was a polymath extraordinaire. He made a major contribution to astronomy with his five-volume *Celestial Mechanics*, in which he was one of the first to suggest the existence of black holes and the concept of gravitational collapse. He also did original work on spherical harmonics. And, in mathematical physics, three revolutionary theories bear his name, the Laplace transform, the Laplacian differential operator, and Laplace's equation. (We would like to

explain all of these, but an insurmountable object stands in our way—our brains.)

In his spare time, Laplace married *une femme magnifique* who was half his age. (He was thirty-nine at the time; you do the maths.)

John Locke
..

John Locke (1632–1704) was a British philosopher, physician, and political theorist, who had enormous influence on several branches of philosophy. He maintained that the human mind at birth is a *tabula rasa*, or blank state, but his own mind didn't stay that way long. In addition to his contributions to liberal democratic theory and the development of the scientific method, Locke was the first to see continuity of consciousness as the key to defining what a self is. He was also among the first to argue for the separation of church and state and for religious toleration. He is often called the father of liberalism, as well as one of the fathers of empiricism. Locke never married.

Niccolò Machiavelli
..

Niccolò Machiavelli (1469–1527) was an Italian historian, philosopher, and diplomat. Some say they don't make diplomats like Machiavelli anymore. Others say they do.

His self-help book on how to gain and maintain power, *The Prince*, remains a bestseller to this day.

A little-known fact about Machiavelli is that he also wrote carnival songs, including the popular ditty "Il Canto de' Ciurmadori" ("Song of the Charlatans"). Very catchy.

Maimonides

. .

Rabbi Moses ben Maimon (1135–1204), a.k.a. Maimonides, was a Jewish philosopher and theologian whose teachings had a profound impact not only on metaphysical and ethical interpretations of the Old Testament but also on the philosophy of the Arab Muslim world, where his writings are still frequently cited. If only Maimonides were alive today, he undoubtedly would make a thoughtful contribution to Mideast peace talks.

Marcus Aurelius

. .

Probably the Stoic best remembered today is Marcus Aurelius (121–180 CE), who was Roman emperor from 161 CE until his death. His *Meditations* is still widely read and widely admired. If chariots had bumpers, Marcus would have been a good source of stickers: for example, "He who lives in harmony with himself lives in harmony with the universe," or "Nothing happens to any man that he is not formed by nature to bear," although these days the latter would probably be shortened to "You Can Do It!"

Herbert Marcuse

. .

In Marcuse (1898–1979) we have yet another philosophical father, this time of the "New Left," the progressive movement in the 1960s and '70s that championed civil rights, gay rights, abortion rights, and drug use rights and argued against the legitimacy of the Vietnam War. Marcuse walked the walk of his liberal moral philosophy, abandoning his homeland, Germany, permanently at the rise of Nazism. Nonetheless, he remained a lifelong member of the internationally influential Frankfurt

School in Germany, criticizing capitalist, fascist, and communist theory and practice.

Personally, we are proud to claim one degree of separation from Marcuse: Our favourite college teacher, the social/political philosopher and Kantian scholar Robert Paul Wolff, was a good friend of his.

Karl Marx

The German economist, sociologist, and philosopher Karl Marx (1818–1883) was the rare philosopher who actually changed the way people lived—millions of them. In Russia, Eastern Europe, China. Need we go on?

Marx's theory of dialectical materialism was not merely a theory of how societies develop and operate, it was a call to revolution. "Workers of the world unite!" quoth Marx and his colleague Friedrich Engels. The world has not been the same since.

J. M. E. McTaggart

The British metaphysician John McTaggart Ellis McTaggart (1866–1925) never satisfactorily explained why his surname crops up twice in his personal quatronym, perhaps because he had other things on his mind. Like Hegelian idealism. He is best known for "The Unreality of Time," in which he argues, naturally, that time is unreal. It was published some time or another.

John Stuart Mill

Talk about overbearing fathers. John Stuart Mill's dad, the historian James Mill, micromanaged little Johnny's time from the

moment he was born in 1806. His home schooling included private tutorials with the social philosopher Jeremy Bentham, the founder of utilitarianism, who implanted that philosophy in the little guy's head. No playmates were permitted; Dad wanted a genius.

John did not disappoint. He was fluent in ancient Greek by the age of three, learned Latin at eight, and knew just about everything—from maths to poetry—by the time he was twelve.

Unsurprisingly after such an upbringing, Mill fell into a deep depression as a young man. In his autobiography, he recounts that he began questioning whether reaching his (and his father's) goal of creating a just society would actually make him happy. And he answered, honestly, No. A basic tenet of utilitarianism is that a just society is based on the greatest good or *happiness* of the greatest number. A sad paradox there.

Nonetheless, John Stuart Mill is remembered as the most influential English-speaking philosopher of the nineteenth century. He died in 1873.

Michel de Montaigne

Because the Frenchman Michel Eyquem de Montaigne (1533–1592), Lord of Montaigne, didn't need to earn his keep, he could hang around the Château de Montaigne and its luxuriant gardens just thinking. And that seems to be pretty much what he did most of the time, pausing now and again to dip his pen in a portable ink jar and jot down his thoughts and perceptions in free-associative essays. Fortunately, he was a marvellous observer and writer, and his expositions (*Essais*) remain to this day models of the elegant and thoughtful personal essay.

What makes Montaigne stand out as a philosopher is that he wasn't given to grand abstract theories or metaphysical sys-

tems. Rather, he made his points by describing his personal deliberations. One of our favourite Montaigne lines is worth quoting: "I quote others only in order the better to express myself."

G. E. Moore

G. E. Moore (1873–1958) was an English philosopher who, along with Gottlob Frege, Bertrand Russell, and Ludwig Wittgenstein, was one of the founders of twentieth-century analytic philosophy. This group was not interested in metaphysical speculation but rather in the careful, painstaking analysis of the meaning and logic of philosophical and scientific statements. They changed the course of Anglo-American-Australian philosophy for the next century, down to the present day.

Moore preferred to be known as G. E. rather than George Edward. His wife insisted on calling him Bill. (See "Feminism.")

Friedrich Nietzsche

The German philosopher Friedrich Nietzsche (1844–1900), son of a Lutheran minister, is probably best known for announcing the death of God. Talk about rebelling against your father—and your Father! By "God is dead," Nietzsche meant that Christianity was, in his opinion, no longer relevant to the modern world. He said "Blessed are the meek" was born out of resentment by the weak for those who had successfully exercised their "will to power." He called the latter people *Übermenschen*, or "overmen." (He apparently couldn't imagine *Überfrauen*, "overwomen.") *Übermenschen* is sometimes unhappily translated as "supermen," calling up pictures of Clark Kent removing his business apparel in a phone booth.

These *Übermenschen* were not bullies; rather, their natural nobility made them fit to rule the common herd without malice.

Unfortunately, Nietzsche developed a severe mental illness in the last decade of his life, possibly caused by syphilis. He spent some time in an asylum, before moving in with his mother, who, along with his sister, cared for him till his death.

On a happier note, Nietzsche's work had a tremendous influence on several twentieth-century philosophers and theologians, including Heidegger, Sartre, Camus, Derrida, and Tillich. On a less happy note, a distorted version of his notions of the "overman" and the "will to power" was used by Nazis to justify their superiority.

Martha Nussbaum

Professor Nussbaum (1947–) is arguably the most renowned American philosopher of the twenty-first century. Well, so far. Although her thinking is firmly rooted in classical Hellenic philosophy—particularly Aristotle—she is thoroughly aware of the influence of cultural norms, as seen in her magnum opus, *The Fragility of Goodness*.

Nussbaum traces her rebelliousness back to her upbringing in a wealthy New York WASP family, replete with class and racial prejudices. Recently, Nussbaum converted to Judaism and had a bat mitzvah. Reportedly, neither cucumber sandwiches nor apricots with *bleu de Bresse* were served at the reception. Too *goyishe*.

Derek Parfit

The recently departed British philosopher Derek Parfit (1942–2017) was considered the superstar of modern moral philosophy.

In part, his general popularity came from the fact that he was just so damned entertaining with his numerous, mind-boggling thought experiments. They read like scripts for heady sci-fi films. But Parfit also enjoyed high esteem in the academic community for his daring attempts to construct a rational basis for ethical principles, something that no philosopher had attempted for more than a century.

Parmenides

Born around 540 BCE in Elea (a Greek colony in Italy) to wealthy parents, Parmenides was a literary type, composing his metaphysics in a very long poem called "On Nature." One part of the poem, with the Zen-like title "The Way of Truth," was about "what-is" (a.k.a. "reality") and his belief that It All was reducible to One Eternally Unchanging Thing. The other part of the poem, "The Way of Opinions," was about how the human mind and sense organs manage to get just about everything wrong.

Parmenides founded a school and taught several influential philosophers, particularly Zeno of Elea, the famous master of the paradox. It is unknown when Parmenides died, or, given his philosophy, whether he died.

Blaise Pascal

Frenchman Blaise Pascal (1623–1662) was stuck in a perennial philosophical pickle: how to reconcile a devotion to the scientific method with a faith in God.

A prodigious mathematician and physicist, he is credited with building one of the first calculating machines, often considered a forerunner of the modern-day computer. Some of his most influential work in mathematics was in the field of probabilities—

calculating odds. In fact, his work on probability theory contributed to the invention of the calculus by another philosopher, G. W. Leibniz. All this calculating proved useful in determining gambling odds and the later development of actuarial science, as well as his famous wager on the existence of God.

Charles Sanders Peirce

Although Bertrand Russell declared, "Beyond doubt [Peirce] was one of the most original minds of the later nineteenth century, and certainly the greatest American thinker ever," the poor fellow didn't get that much recognition during his lifetime. Indeed, Peirce's life story reads like one long stroke of bad luck.

Peirce (1839–1914) suffered from episodes of a painful facial neurological disease, which often left him depressed; he was shunned by his alma mater (Harvard's president Charles Eliot couldn't stand him); and he was terrible with money (an investment in a Pennsylvania farm went bust). But Peirce forged on with his articles about mathematics, logic, chemistry, linguistics, experimental psychology, and metaphysics, and eventually became known as one of the fathers of American pragmatism, along with William James and John Dewey.

Plato

Long before there was "Madonna" or "Sting" or "Beyoncé," there were mononymous Greek philosophers like Socrates, Aristotle, and, the most famous of them all, Plato (428–347 BCE). One reason these philosophers got away with a sole, unaccompanied moniker is that there weren't that many people hanging around the Acropolis in the Golden Age of Greece. "Plato" unambiguously named one guy.

And what a guy! Plato is considered the founder of Western philosophy, and at that time the discipline of philosophy pretty much covered everything there was to know: science, mathematics, moral reasoning, cosmology—the entire curriculum in a single course. Plato's dialogues are considered the foundation of everything that followed, so much so that the twentieth-century British philosopher Alfred North Whitehead declared that "the safest general characterization of the European philosophical tradition is that it consists of a series of footnotes to Plato."

Karl Popper

Sir Karl Popper (1902–1994), a Vienna-born philosopher who taught at the London School of Economics, is best known for his contributions to the philosophy of science, although he also wrote extensively on political philosophy and theory.

In 1946, Popper was invited up from London to deliver a paper called "Are There Philosophical Problems?" to the Moral Sciences Club at Cambridge University. The session was chaired by Ludwig Wittgenstein, a Vienna-born philosopher who taught at Cambridge. It didn't go well. Sir Karl and Wittgenstein started vehemently fighting with each other over the difference between a "philosophical problem" and a "linguistic puzzle." At one moment, Wittgenstein pulled a hot poker out of the fireplace and started punctuating his philosophical points with the point of the poker near Popper's face. No one was hurt. The spat was memorialized in David Edmonds and John Eidinow's bestselling book *Wittgenstein's Poker*.

Willard Van Orman Quine

..

W. V. O. Quine (1908–2000) grew up in Akron, Ohio, where his father was an entrepreneur and his mother a schoolteacher and housewife. He studied mathematics at Oberlin and philosophy at Harvard, receiving his doctorate in 1932. During the war, he served as an intelligence officer, deciphering German messages.

Quine was able to lecture in French, Spanish, Portuguese, and German. Rumour that he could also lecture in Arunta have a high mathematical probability of being apocryphal.

John Rawls

..

The American political philosopher John Rawls (1921–2002) is best known for his 1971 book, *A Theory of Justice*, in which he defines justice as fairness and creates his famous "veil of ignorance" test of fairness.

In his youth, two tragic events may have played a role in his sense of the unfairness of life. Two younger brothers contracted serious diseases from him—diphtheria and pneumonia—a year apart, and both died.

After graduating from Princeton in 1943, he served in the infantry in the South Pacific until the end of the war. He went on to teach at Princeton, Cornell, MIT, and Harvard.

He is considered by many to be the preeminent political philosopher of the past century.

Jean-Jacques Rousseau

..

Jean-Jacques Rousseau (1712–1778) was a Genevan (at the time, this made him French rather than Swiss) philosopher, novelist,

composer, and memoirist. His passionate arguments for the equality of man are considered a factor in fomenting the French Revolution.

His autobiography, *Confessions*, initiated the literary movement known as the Age of Sensibility, a deeply introspective form of writing.

Bertrand Russell

British Nobel Prize winner Sir Bertrand Arthur William Russell (1872–1970), the third Earl Russell, was a powerhouse—a logician, mathematician, and historian of the first order. Along with Frege, Moore, and Wittgenstein, he revolutionized philosophy with the application of analytic logic to philosophical discourse. In his nine-plus decades of life, he was also a highly regarded liberal political activist and pacifist. And, not that it really matters, he was also known as a ladies' man, or, as one friend quipped, he suffered from "galloping satyriasis."

Sappho of Lesbos

Even the writer of caption-size biographies is challenged by writing one for Sappho. No reliable records of her life have ever been found. Still, she is remembered for lending her name to a term for female homosexual love ("sapphic love") and ditto for lending the name of her homeland, Lesbos, for practitioners of that love. But mostly she is remembered for her romantic poetry, most of which did not survive her lifetime and therefore has not been read since. In other words, Sappho of Lesbos is well remembered, but not remembered well.

Jean-Paul Sartre
..

Jean-Paul Sartre (1905–1980) was a French intellectual known for his plays, his leftist political writings, and especially for his philosophical magnum opus, *Being and Nothingness*. Many readers found the "Being" part more substantial than the "Nothingness" part.

Sartre was captured during the war and spent nine months in a German prison camp. After the fall of France to the Nazis, he participated briefly in the French underground before choosing a life of writing. He was awarded the Nobel Prize in Literature in 1964, but, consistent with his philosophy of radical human freedom, he declined the prize, saying he did not want to become "institutionalized." In fact, he renounced literature, calling it a bourgeois substitute for a life of commitment in the real world.

Sartre's life exemplified his strong commitment to humanitarian causes, despite his belief that human existence was ultimately absurd. Don't ask. Please.

He enjoyed a lifelong, though not monogamous, relationship with the French feminist intellectual and philosopher Simone de Beauvoir, with whom he shares a grave. Both apparently are finally monogamous.

Julian Savulescu
..

Australian bioethicist Julian Savulescu (1963–), editor of the prestigious periodical the *Journal of Medical Ethics*, is wild about the advantages that modern technology provides for humankind. And it's not just performance-enhancing drugs either.

Savulescu is a proponent of what he has dubbed "procreative beneficence." He says that prospective parents with access to DNA data about their gestating offspring are morally obligated to bear only the children who have the best possible lives ahead of them. And, of course, to terminate those with less than promising lives ahead. In other words, to take survival of the fittest into our own hands and with our own values.

It's that "best possible lives" part that confuses and angers his critics, like those who subscribe to the "Beethoven fallacy": i.e., if Ludwig's mother had had access to her embryonic son's DNA profile, she would have seen the marker for early-onset deafness and consequently aborted him, thus putting an end to the "Ode to Joy" before it even began.

Arthur Schopenhauer

Arthur Schopenhauer (1788–1860) was born in the Free City of Danzig, now in Poland (Gdańsk), but when he was five, his family moved to the Free City of Hamburg, now in Germany, perhaps causing the young Schopenhauer to say with a sigh, "If you've seen one Free City, you've seen them all." His father was a highly successful merchant and groomed Arthur to take over the family business. Nonetheless, he offered the young Arthur a choice: take a tour of Europe and apprentice with a merchant, or study to prepare for a university education. Arthur chose the trip and saw firsthand the terrible suffering of the poor. This was step one on his way to his pessimistic understanding of existence. A further step was the death of his father when Arthur was seventeen, possibly of suicide. And another was when his mother told him when he was thirty that she never wanted to see him again. Bummer.

John Searle

Although mainly known as a philosopher of mind and a philosopher of language, John Searle (1932–) has always been a political activist as well.

As an undergraduate at the University of Wisconsin in the 1950s, Searle was a leader in the liberal movement to unseat Wisconsin senator Joseph McCarthy. In the 1960s, as a tenured professor at UC Berkeley, he joined the student-led Free Speech Movement. After 9/11, however, he argued for a neoconservative, interventionist foreign policy. It is unknown if his motivation was the desire to distinguish himself from a computer by appearing totally inconsistent.

Sydney Shoemaker

Sydney Shoemaker (1931–) is the retired Susan Linn Sage Professor of Philosophy at Cornell University. His most famous contributions to modern philosophy are found in his books *Self-Knowledge and Self-Identity* and *The First-Person Perspective and Other Essays*. It is rumoured that after a few martinis, he refers to himself in the third person.

Henry Sidgwick

Henry Sidgwick (1838–1900) was a British thinker, best remembered today for his ethical philosophy. He was a fellow of Trinity College, Cambridge, and taught classics before being named professor of moral philosophy. His *Methods of Ethics* is considered by many to be the most important ethical work in English of the nineteenth century.

Sidgwick was active in promoting higher education for women, founding Newnham College, Cambridge, where his wife became principal. He was also interested in paranormal phenomena and was a founder and first president of the Society for Psychical Research. The rumour that he grasped some of his self-evident moral principles in conversation with extraterrestrials has never been corroborated.

Peter Singer

Peter Singer (1946–) is a contemporary philosopher who focuses on practical moral issues like animal rights and infanticide—he is a proponent of infanticide in certain circumstances. Understandably, Singer is easily the most controversial philosopher around today, to the point that many have called for his ouster from Princeton University, where he teaches.

Unlike most philosophers, who in general approach ethics from an abstract, theoretical point of view, Singer is an applied ethicist and is known to his readers and students for his thought experiments on possible real-life scenarios in which moral decisions need to be made. He bases his own moral decisions on what he calls a "secular utilitarian" perspective, although recently he has revised his label to "hedonistic utilitarian," which sounds like much more fun.

B. F. Skinner

Burrhus Frederic (call me "B.F.") Skinner (1904–1990) was the most influential American psychologist of the twentieth century. As both a psychologist and a philosopher of science, he championed a radical model of behaviourism that made us all

into no more than a bundle of natural and automatic responses to stimulants in the environment. In exploring his notion of controlling the environment to change its effects on us, he created a device that came to be known as the "Skinner box" to analyse animals' responses to rewards and punishments. Indeed, he was rumoured to have put his child Deborah in a Skinner box for long periods during her childhood. The details of the rumour expanded exponentially. The story grew to include that, at thirty-one and psychotic, she sued Skinner for abuse, lost the case, and shot herself in a bowling alley in Billings, Montana. Nice use of detail! But, fortunately for Deborah, if not for storytellers, none of it was true, including her being placed in a Skinner box. Instead, she apparently slept as an infant in an incubator-like structure, controlled for temperature, that had nothing to do with stimulus-response training. She's now an artist in England and reports that she is quite happy and normal, thank you.

It does make you wonder, though, about the psychology of rumour and how the pleasure of gossip can apparently determine the invention of a wacky story about a suicide at Billings Lanes.

Socrates

Socrates (470–399 BCE) was the ur-philosopher, the father of Western thought. He is also the father of the aptly named Socratic method—dialectical reasoning via questions and answers, as in the Socratic dialogues. Although Socrates didn't take the time to jot down his philosophical insights about ethics, politics, and metaphysics, he had two followers, Xenophon and Plato, who recorded virtually every word he said.

Or did they? Could it be that Plato actually passed off his own philosophy as that of Socrates in a kind of ancient Greek lip sync?

You had to be there to know for sure.

Herbert Spencer

Herbert Spencer (1820–1903) was an English sociologist and philosopher, best known for his early advocacy of Darwin's theory of evolution and the application of it to society. He coined the term "survival of the fittest," and his philosophy of "social Darwinism" was used to justify dog-eat-dog competition, which he thought would improve society generally. In other words, he was the intellectual godfather of radical conservatism. These views got him in a lot more hot water than his violation of the "naturalistic fallacy."

Benedict de Spinoza

Spinoza (1632–1677), the son of Jewish parents who had fled to Amsterdam from Portugal to escape the Inquisition, was educated in the Talmud and Torah school of his congregation but dropped out to join his father's business. Later on, he became a lens grinder, exacting work that paid very little. He didn't mind in the least; he preferred the life of the mind to a life of acquisition.

Along the way, he was exposed to a wider world than he had found in his synagogue, including a group of religious free-thinkers who met to study theology, philosophy, science, and the works of Descartes. At the same time, he did not neglect his own cultural tradition and studied the work of the great Jewish philosopher Maimonides.

Nonetheless, Spinoza was eventually declared a heretic and excommunicated by his synagogue. Other members of the congregation were forbidden to communicate with him or read his work. His liberal political and theological views later got him in trouble with the wider community as well, and, for this reason, he chose not to publish his magnum opus, *Ethics*. It was eventually published after his death, but the next year his works were banned throughout Holland. They believed it was the ethical thing to do.

Judith Jarvis Thomson

American philosopher Judith Jarvis Thomson (1929–) is best known for her defence of abortion and her use of thought experiments, such as her variations on Philippa Foot's trolley problem. She combined these two interests in her well-known violinist scenario. She asked us to imagine waking up and finding ourselves hooked up to a famous violinist with a fatal kidney ailment. You have been kidnapped by his devotees because you alone have the right blood type to keep him alive by using your kidneys. You are told you must remain hooked up to him for nine months until he heals.

Her conclusion is that it would be ethical to remove yourself from him, because you have a right to control your own body. Applying that logic to abortion, she concluded that we do not have to argue that the foetus is not yet a person; we have only to argue that women have a right to control their own bodies.

Alfred North Whitehead

Alfred North Whitehead (1861–1947) was one of the Big Brains of British logical theory, penning that perennial philosophy bestseller *Principia Mathematica* with fellow Big Brain Bertrand

Russell. In three large volumes, the *Principia* catalogs the foundations of mathematics. It is suitable bedtime reading for other big brains.

Later in his career, Whitehead turned his mind to the philosophy of science and metaphysics. This gave birth to his theory that reality is not so much a bunch of objects as it is a megasystem of constantly developing, interrelated processes (see his *Process and Reality*). Central to process philosophy is Whitehead's contention that human beings are partially responsible for how these various processes work out. Recently, Whitehead's notion of personal responsibility for natural processes has been championed by environmental philosophers.

Ludwig Wittgenstein

Ludwig Wittgenstein (1889–1951) was born in Vienna into an extremely wealthy family that was deeply involved in the world of Viennese culture at the turn of the twentieth century.

By any standard, he was an odd duck. He could work himself into a lather, pacing back and forth, criticizing his own work and that of other philosophers. His teacher at Cambridge, Bertrand Russell, considered him a genius; many of his own students at Cambridge were afraid of him.

After the First World War, he became extremely depressed and gave his substantial inheritance to his siblings. He considered committing suicide, as three of his brothers had done.

After his early work, the *Tractatus Logico-Philosophicus*, was published in 1921, he thought he had brought philosophy to a close and retired to a remote Austrian village to teach in an elementary school, where he was known to hit students who made mistakes in mathematics.

He returned to philosophy when he became obsessed with the many and varied ways in which language is related to the world. His perfectionism kept him from publishing, and his *Philosophical Investigations* was put together from his manuscripts and published two years after his death.

On a more upbeat note, during the Second World War, he volunteered as a hospital porter, hiding the fact that he was a world-famous philosopher.

Zeno of Elea

Unsurprisingly, Zeno of Elea was born in Elea—in southern Italy. Historians think he was born around 495 BCE and died around 430 BCE. Because Parmenides had taught him that movement is a logical impossibility, he didn't move much. Plato says he went to Athens with Parmenides and met Socrates, but Plato often made stuff up to jazz up his dialogues.

The truth is we don't really know much about his life, but one apocryphal story is a hoot. He allegedly got arrested for arms-running for the rebels who were trying to overthrow the reigning despot in Elea. When asked to reveal the names of his coconspirators, he asked if he could whisper in the despot's ear. Zeno then supposedly bit him and wouldn't let go until they stabbed him. Perhaps his lawyer used the "movement is impossible" defence.

Acknowledgements

Acknowledgements

Samara Q. Klein, Danny's daughter, read and critiqued our penultimate draft of this book, leading us to make critical changes for clarity. She's one smart cookie and we are grateful.

Patrick Nolan and his fabulous assistant, Matthew Klise, were our tender shepherds from start to finish. We shall not want.

As always, our wives, Eloise Cathcart and Freke Vuijst (Klein), were patient bystanders as we worked away, shirking household responsibilities. We will make it up to them. Very soon. No, really.

Also, a nod of appreciation goes to Esther Cathcart for being both supportive and funny.

And finally, a word about the person to whom we dedicated this book, our agent and friend, Julia Lord. We couldn't ask for a better partner.

Image Credits